A BRIEF, LIBERAL, CATHOLIC

DEFENSE OF ABORTION

A Brief, Liberal, Catholic Defense of Abortion

DANIEL A. DOMBROWSKI

AND ROBERT DELTETE

University of Illinois Press

Urbana and Chicago

Library of Congress Cataloging-in-Publication Data
Dombrowski, Daniel A.
A brief, liberal, Catholic defense of abortion / Daniel A.
Dombrowski and Robert Deltete.
p. cm.
Includes bibliographical references and index.
ISBN 0-252-02550-4 (acid-free paper)
1. Abortion—Religious aspects—Catholic Church.
I. Deltete, Robert John. II. Title.
HQ767.3.D62 2000
241'.6976—dc21 99-6707
CIP

C 5 4 3 2 1

Contents

Introduction

THERE IS A SAYING from Thucydides to the effect that it is not difficult to praise the Athenians in Athens, but it is quite difficult to praise the Spartans there. Equally difficult is the effort to defend a "pro-choice" stance regarding abortion in the Catholic church. It is usually assumed, both within and outside of Catholicism, that opposition to abortion just *is* the Catholic view, to such an extent that even if there are debates within Catholicism regarding the ordination of women, celibacy, contraception, homosexuality, premarital sex, et cetera, Catholics are at least united, or almost so, in their opposition to abortion.

But the matter is not so simple. In fact, a significant minority of Catholics have a quite liberal view of abortion. It will be the purpose of this book to defend their stance; indeed, we will defend it by claiming that the Catholic "pro-choice" stance is at least as compatible with Catholic tradition as the anti-abortion stance, and may even be more compatible with Catholic tradition than the *current* anti-abortion stance defended by many Catholics and by most Catholic leaders. We contend that most twentieth-century Catholic theology on abortion is a caricature of the rich and variegated tradition in Catholicism on this topic.

Our argument can be stated in abbreviated form as follows:

1. Opposition to abortion (A) in the history of Catholicism has been based at different times on two sorts of argument: the ontological position (B) or the perversity position (C). Hence, if one wishes to oppose abortion on Catholic grounds, one is most likely to do so on the basis of (B) or (C) or some combination of (B) and (C).

2. But the ontological position (B)—where the ontological status of the fetus as a human person, even in the early stages of pregnancy, is crucial—is not the traditional position in Catholicism. We will argue that this position was opposed by Saints Augustine and Thomas Aquinas. Moreover, we will also argue, (B) seems to be based on certain mistakes made in seventeenth-century science.

3. The perversity position (C)—the view that abortion is a perversion of the true function of sex regardless of the ontological status of the fetus—provides the traditional grounds in Catholicism for opposition to abortion, but very few contemporary Catholics oppose abortion on these grounds. Nor should they, since (C) rests on a defective view of sexual ethics, as we will argue, in that the perversity view does not sufficiently incorporate within its borders the concepts of mutual respect and Christian love (agape).

4. Given the weaknesses of these two positions, contemporary opposition to abortion in Catholicism is on a shaky foundation, at best, and should be significantly altered or dropped.

The above argument can be put more formally as follows:

1. $A \Rightarrow (B \lor C)$.
2. $\sim B$.
3. $\sim C$.
4. $\therefore \sim A$.

The purpose of this book is to focus the debate within Catholicism regarding abortion. The above argument is formally valid, but our opponents will perhaps suggest that it is not sound; they will suggest, we suspect, that one of the three premises is not true. In any event, we hope to be as clear as possible in this book so that our opponents will be able to state exactly where they

disagree with our position. By stating the case for a liberal Catholic stance on abortion in bold terms (which is not the same as overstating it), we will be better able to discover through dialectical exchange what the strengths and weaknesses are of the position we propose. As Karl Popper has argued, tentativeness (as opposed to boldness) is an overrated intellectual virtue in that, although it creates a certain illusion of safety surrounding the theories one cautiously defends, it also makes it less likely that one will find out where one's errors are and less likely that one will make intellectual progress by asymptotically approaching the truth regarding the subject matter in question.

The chapters are arranged so as to flesh out the bare bones of the above argument. Chapter 1 treats the views of abortion found in Saints Augustine and Thomas Aquinas, views that rest foursquare on the perversity position and not on the ontological one. Despite the ready availability of the relevant texts, the fact that neither Augustine nor Thomas—two of the most important thinkers in the history of Catholicism—saw the fetus in the early stages of pregnancy as a human person is still one of the best kept secrets in the history of Catholicism, indeed, within the entire history of ideas. In fact, Augustine remarkably compares the fetus in the early stages of pregnancy to vegetation (as we will see in chapter 1).

No doubt the casuistic method of the sixteenth century is different from the scholastic method of the thirteenth, and both of these are different from the penitentials of the sixth to the ninth centuries, and all of these are different from the style of Augustine. But we will see that delayed hominization in some form or other was the norm in the premodern period, a fact that is crucial for our thesis in this book.

Chapter 2 treats the rise in popularity of the ontological position, apparently as a result of some scientific developments in the seventeenth century. We will consult the writings of Fathers H. de Dorlodot and E. C. Messenger, the Jesuit Joseph Donceel, and others to argue that this position seems to rest on certain mistakes made in seventeenth-century science by those who were infatuated with new pieces of technology that they both

used and abused; namely, magnifying glasses and especially Leeuwenhoek's microscope. By the end of chapter 2, the problem faced by contemporary opponents to abortion in Catholicism will be apparent: once the historical contingency of and the glaring defects in the ontological position are on the table, one must either: (i) revert back to the perversity position, or (ii) create some new, ersatz defense of the ontological position that has little to do with the history of Catholicism, or, as we will urge, (iii) drop one's opposition to abortion in the early stages of pregnancy.

Chapter 3 considers the role of the concept of God in theorizing in a Catholic context about abortion. Specifically, we will be concerned with the relationship between the present and the past, on the one hand, and the relationship between the present and the future, on the other, for beings like fetuses who are not eternal. We will rely heavily in this chapter on the thought of Charles Hartshorne in an effort to trace the connection between belief in divine omniscience and one's attitude toward the issue of abortion. Here we will see that a liberal Catholic version of divine omniscience is required to defend a liberal Catholic stance on abortion. In this chapter, moreover, we will address those opponents to abortion who rely primarily on potentiality arguments in favor of the view that moral respect is due to fetuses early in pregnancy.

In chapter 4 we sketch a liberal Catholic view of sexual ethics, a view that is meant to counteract the perversity positions of Augustine and Thomas. These thinkers oppose abortion precisely because abortion indicates that the sex that resulted in the fetus to be aborted was perverse. This view, we will claim, insufficiently incorporates a concern for mutual respect between sexual partners and for Christian agape.

The designation of our position as "liberal" will be explored in chapter 5, the last chapter of the book. In one sense, "liberal" refers to a use of the term that is found in popular culture, in popular culture in the United States at least, where the "liberal" view of abortion (the "pro-choice" stance) contrasts with the "conservative" view (the "pro-life" stance). But this use of terms cannot be the whole story if our liberal view conserves more of

the Catholic tradition on abortion than the supposed "conservative" view. For example, Augustine's and Thomas's belief that the fetus is not a human person in the early stages of pregnancy is not conserved—indeed, it is contradicted—in the contemporary "conservative" position. In another use of the term, "liberalism" refers to contemporary political liberalism. In this sense of the term, we will argue, "liberalism" is both compatible with Catholic social teaching and conducive to a healthy spirit of toleration in Catholicism that is not necessarily connected to relativism, to selfishness, or to a denigration of tradition, in spite of what some of contemporary liberalism's Catholic detractors say.

An afterword treats the argument from marginal cases, an argument that will help to clarify our view.

We should also note that our defense of a liberal "Catholic" stance regarding abortion is not intended in a narrow, sectarian way. For example, the contemporary philosopher of religion and metaphysician who is most influential regarding what we say in chapter 3 is Charles Hartshorne, the son of an Episcopal minister. And although Catholics are the primary audience for this book, it is written in such a way as to be of interest (we hope) to all who are concerned about the abortion debate: Protestants, Jews, agnostics, et cetera. Hence, in many ways our book could be titled "A Brief, Liberal, Christian Defense of Abortion" or "A Brief, Liberal, Religious Defense of Abortion." But we have kept the word "Catholic" in the title for three reasons. First, we are Catholics rather than free-floating theists, and we would like to contribute in a positive way to an ecumenical and cross-cultural debate on the topic of abortion from the particular position from which we start. Second, the key points in the history of opposition to abortion all occur within the history of Catholicism: Augustine's defense of the perversity position in the fifth century, Thomas Aquinas's defense of delayed hominization in the thirteenth century, and the gradual switch to the ontological position that was started in the seventeenth century by various thinkers, many of whom were Catholic.

And third, our view is Catholic in the sense that the method we have used is based on deductive reasoning that follows from

a premise regarding the ontological status of the fetus. The Catholic position of Daniel Callahan that has gotten most attention today goes something like this:

A. God alone is the Lord of life.
B. Human beings do not have the right to take the lives of other (innocent) human beings.
C. Human life begins at the moment of conception.
D. Abortion, at whatever the stage of development of the conceptus, is the taking of innocent human life.
E. The conclusion follows: Abortion is wrong. The only exception to this conclusion is in the case of an abortion that is the indirect result of an otherwise moral and legitimate medical procedure (e.g., the treatment of an ectopic pregnancy and cancerous uterus).[1]

The meaning of "human life" in premises C and D is obviously crucial. In fact, Callahan is correct to highlight the fact that (contemporary) Catholic authors tend to make the beginning of human life the major, indeed the overriding, question to be answered in any approach to abortion. In this regard we are very Catholic writers, since other questions—including important ones concerning feminist perspectives on the abortion issue—sometimes assume secondary status. (This is not always the case, however, because to hold the mistaken view that we should value *all* prenatal life as much as we do the lives of adult women denigrates women, such that they are of no more value than mere fertilized eggs.)[2] For example, a woman cannot really have an *absolute* right over her own body if very few, if any, reasonable persons would grant that she is free to intentionally take thalidomide during pregnancy and to carry the fetus to term. Although we disagree with contemporary Catholic opponents to abortion, we nonetheless admire their concern for innocent human life.

But "human life" can mean at least two different things, as we will see, and distinguishing between these two different meanings will be crucial in our effort to argue against premises C and D above. First, it can merely mean that something is alive with human genetic material or that it has human parents; and second, it can mean being alive in a sophisticated enough way that

it qualifies as a human *person,* with sentiency a necessary condition for human personhood, as in Augustine and Thomas Aquinas. One of the problems with intellectual debates on abortion issues is that there is no commonly agreed-on set of technical terms to deal with the moral issues; however, our own stipulative definition of terms will include the above distinction between merely being human in the sense that one has human genetic material or human parents, on the one hand, and being a human person in some morally relevant sense, on the other. Further, we will try to avoid speaking vaguely about when "life begins," since plant cells, paramecia, individual sperm cells, et cetera, are alive. The important question, as we see things, is when prenatal life becomes sophisticated enough that it can be coherently seen as a moral patient.

We will not be spending a great deal of time in this book on the interesting issues regarding late-term abortions to save the mother—issues that have led to complicated uses of the principle of double effect, despite the simple language found in step E above in the argument stated by Callahan. On this principle, a fetal craniotomy might not be allowed, but removing a cancerous uterus might be allowed, to save the life of the mother. Rather, by "abortion" we will normally be referring not to spontaneous, natural abortions (or, in some cases, "miscarriages"), nor to induced, indirect abortions (as in removing the cancerous uterus that contains a fetus to save the life of a pregnant woman), but to induced, direct abortions, of which we will make what we take to be—and what we assume Augustine and Thomas took to be—an all-important distinction between abortion relatively early in pregnancy and abortion relatively late in pregnancy.

Our procedure will exhibit the following sort of relationship with tradition, in our case with Catholic tradition, as articulated by Josiah Royce in *The Philosophy of Loyalty:* "Whenever I have most carefully revised my moral standards, I am always able to see . . . that at best I have been finding out, in some new light, the true meaning that was latent in old traditions. . . . Revision does not mean mere destruction. . . . Let us bury the natural body of tradition. What we want is its glorified body and its immortal soul."[3]

The need for the present book becomes painfully apparent when one considers the work of several contemporary scholars, in particular, to be treated in chapter 2, who criticize the current popularity of the ontological position in Catholicism but who shy away from an explicit *defense* of the right of a woman to an abortion in the early stages of pregnancy. That is, it is quite common to find philosophers and theologians and historians of ideas who criticize the current "pro-life" stance popular in Catholicism, and who at least half-admit that the traditional attitude toward abortion was informed by the perversity view and not the ontological one; but it is not common to find these scholars actually defending a "pro-choice" position on a Catholic basis. Thus, as we see things, there is a pressing need for something like the present book, although we would not have been able to take on this project without the pioneering work done by scholars whose views of the subject in question are very similar to our own (especially Daniel Maguire and Joseph Donceel, S.J.).[4]

In this book we will be defending a view of abortion that relies on certain more general philosophical views, most notably a process or neoclassical version of dynamic hylomorphism (to be discussed later) and a related version of the interest principle: interests are essential to rights and a capacity for conscious awareness is a necessary condition for the possession of interests. By "interests" here we do not mean what is in the interest of a being (in this sense even automobiles have interests), but rather a reference to those beings who can *take an interest in* certain things. These general theories are needed so as to avoid "cooking the evidence," since ethical theory should not be driven by the purposes to which it is put, but neither is a complete ethical theory necessary in order to do applied ethics.[5]

Despite the fact that we will cite certain theological sources in this book, we emphasize that we are philosophers and not theologians. Hence our argument in this book will at times illustrate some of the classical tensions between these two disciplines. It is obviously not our aim to deal in detail with these tensions, except to say that while, like most philosophers, we do not view our discipline as the handmaiden of theology, neither

do we think that most contemporary philosophers are correct in largely ignoring theological sources when dealing with difficult moral issues.

We end this introduction by briefly summarizing the biology of fetal development, so as to explicate some basic terms that will be used throughout the book and to indicate the scientific account of such development points that we will assume throughout. The biology of fetal development that we will assume is documented in at least two different sorts of literature. First, there are the embryology textbooks used in medical schools, books that stay abreast of the latest discoveries in the understanding of fetal development.[6] Second, there are two useful summaries of recent scientific understanding of fetal development intended for intelligent laypersons: one by Harold Morowitz and James Trefil and the other by Clifford Grobstein.[7] All of these sources offer a picture of fetal development that is compatible with, indeed that supports, the Catholic defense of abortion that we will offer.

In what follows, we will generally use the term "fetus" in a broad sense to refer to life inside the womb from the "moment" of conception to birth, although we will often qualify this term when we refer to various stages of fetal development: early and late. In context the reader should be able to understand easily what we mean by "early fetus" or "late fetus." In order to develop our argument, it will usually be sufficient to refer to the fetus (or the early fetus) in this broad sense.

At some points greater precision will be needed, as we will see momentarily. Most of the cells in an adult human being have a full complement of genetic material. Some cells, however, namely the cells that figure in reproduction, have only half the normal complement. The latter cells are called "gametes," but we will refer to them by the usual terms "sperm" and "egg." As is well known, when a sperm and an egg come together in the process of reproduction, each contributes half of the offspring's genetic material. Equally well known is the fact that contemporary opponents to abortion think that this coming together is *the* significant event in considering the morality of abortion; but we will argue at various points that the matter can be seen in a dif-

ferent light, especially when Augustinian and Thomistic tradition is brought into play.

Human beings are among the small percentage of animals that are vertebrates, animals with nerve cells organized to form a long chord down the back protected by a backbone. More specifically, human beings are a type of vertebrate in the hominid family in the genus *Homo*, and whose species designation is *sapiens*. There is indeed something special about *Homo sapiens*, as opponents to abortion argue, at the very least because all other members of our hominid family and the *Homo* genus are extinct. Human beings are distinct in other ways that we will discuss later, ways that are connected to their sophisticated central nervous systems and highly complex brains.

Cells in a human body need to make proteins, and they only know the proper sequence for the amino acids they put together when making proteins as a result of deoxyribonucleic acid, or DNA. This is the "molecule of life" because it contains the information for making all of the proteins that drive reactions in cells. The DNA in the nucleus of human cells is contained in forty-six separate strings called "chromosomes." The information that is in the DNA is eventually hooked on to other cellular material to form a larger molecule called RNA, for ribonucleic acid. The point we will emphasize is that in the earliest stages of pregnancy the fetus (in the broad sense of the term) is obviously human in the sense that it has human genetic material in its DNA and RNA molecules and that it has human parents. But it is an open question whether the fetus in the earliest stages of pregnancy is human in the moral sense, whether it can be seen as a moral patient capable of receiving harm. We will argue, relying on Augustine and Thomas, that moral patiency occurs much later in pregnancy.

Conception is just one link in a chain of events that might eventually lead to birth. The act of fertilization usually takes place in one of the two Fallopian tubes, which connect the ovaries to the uterus. The nuclei of the egg and sperm merge, producing a new nucleus containing a full complement of genetic material. The single cell resulting from the fertilization of the

egg is called a "zygote." During the next four days the zygote (usually) travels down a Fallopian tube to the uterus and starts to divide; when certain cell divisions occur it is called a "blastocyst." Six days after fertilization the blastocyst implants itself, usually in the wall of the uterus, after which it is called an "embryo." Around sixty days after fertilization the embryo is technically called a "fetus," although, as we have noted, we have usually used the term "fetus" in a less technical and broader sense throughout the book to refer to that which is living inside the pregnant woman throughout pregnancy. When we refer to a fetus in the early stages of pregnancy, unless otherwise noted we will be pointing to the entire period from zygote to blastocyst to embryo to the development of sentiency and a functioning cerebral cortex. When we refer to a fetus in the later stages of pregnancy we will be pointing, unless otherwise noted, to fetal development after the development of sentiency and a functioning cerebral cortex.

Although potentiality arguments will be considered in detail in chapter 3, it is worth mentioning here that the probability that a zygote will result in a full-term pregnancy is low. Data here are not exact, since no one knows how many late menstrual periods are actually early miscarriages as opposed to temporary dysfunctions in the menstrual cycle. In any event, not all zygotes actually complete the trip down a Fallopian tube, and not all blastocysts implant in the wall of the uterus. The best estimate that scientists can currently make is that fewer than one-third of all conceptions lead to a fetus that has a chance of developing until birth *quite apart from* human intervention. It is not true that all, or even most, zygotes would have become human beings in the absence of abortion. Nature performs abortions at a rate much higher than any human society.

Biologically the most distinctive thing about human beings, in contrast to the rest of the living world, is our enlarged cerebral cortex. We will see that Teilhard de Chardin and Bernard Häring, Catholic priests, think that the *personal* manifestation and activities of human beings are due to the cerebral cortex, a view that is at least consistent with that of Saints Augustine and

Thomas Aquinas. In the first days of development, a zygote shares basic chemical properties with other living things, and when the zygote produces a ball of cells called a "blastula" there is a system resembling that in the simplest animals, but it takes quite some time for the cerebral cortex to function. In fact, scientists early in our century who wanted to study the blastula did so by considering the properties of sea urchins. By the end of the second week of pregnancy, the "primitive streak" is present, which is the *beginning* of the central nervous system, but it is not yet a functioning central nervous system.

It is during the second month of pregnancy that most of the major organs *start to* form in the fetus. By six weeks the fetus is recognizably human *in the sense that* it has a rudimentary face, limbs, and so on. Opponents to abortion might be tempted to think that the early fetus is therefore a complete human being in miniature, such that from this point on all that happens is that everything grows proportionately larger until birth. But inside the fetus an enormous amount of *structural* change and differentiation, not merely growth, still needs to occur, especially in the central nervous system, and most especially in the brain.

Not until the second month does the fetus achieve "vertebrateness" in the sense that the neural tube has closed off and the cells lining it near the top have grown to form a curved structure. It is not until the third month, however, that the fetal brain is even recognizable as mammalian. The development of the central nervous system occurs in stages, whereby cells migrate to a region so as to make the basic outline of a large structure, and then they gradually differentiate to put the structure in its final form. The brain does not function until the differentiating work is done. That is, the fact that there *appears* to be a brain at four months should not lead us to conclude that there really is a functioning brain, much less a cerebral cortex, at that point.

Other vertebrates (even fish) have brains with a cerebrum, but something qualitatively different occurs when a very large cortex makes possible the distinctively human functions associated with our rationality. As we move through the vertebrates, a greater fraction of brain weight is taken by the cerebral cortex,

until it reaches 70 percent in human beings. Once again, however, it is not just a quantitative increase at work here, but a qualitative one made possible by our large cerebral cortex. Or more precisely, the functioning of the cerebral cortex is properly understood not merely in terms of its gross anatomy but also in terms of the qualitative changes made possible by the relatively sharp boundaries in time that occur with respect to cells in the brain. Two separate processes can be distinguished: *first* the growth of cells that make up the brain and *then* the establishment of connections among them. Only when *both* of these tasks are completed has a fetus acquired the properties that distinguish it qualitatively from other animals.

What distinguishes a nerve cell from other cells in the body is not the fact that it has electrical activity at its surface, since every living cell has some sort of electrical activity at its surface. Rather, nerve cells (and some muscle cells) have the ability to change the arrangements of electrical charges quickly. At any given moment, a nerve cell performs a complex operation whereby it integrates all of the signals it receives and then fires or not, a firing operation that is an all-or-nothing affair. The gap between a nerve ending (a "bouton") and a neighboring cell is called a "synapse." It is synapse formation that makes it possible for nerve cells to communicate with each other, and series of synaptic formations and connections that make it possible for the cerebral cortex to function.

To use a helpful metaphor from Morowitz and Trefil, a pile of wires and switches is not an electrical circuit, and a collection of nerve cells is not a functioning brain. The wires and switches need to be connected in order to make a circuit or a computer, and the nerve cells in the cortex need to be connected for there to be a functioning brain. In effect, before synapses are sufficiently formed the brain does not function because it is just a collection of nerve (and other) cells. The burst of synapse formation, and hence the start of the cerebral cortex as a functioning entity, occurs between twenty-five and thirty-two weeks, and in most cases toward the end of this range. It is this period that can legitimately be seen as the one that gives rise to what is distinc-

tively human from a biological point of view. Or, at the very least, this view is as plausible as that put forward by contemporary Catholic opponents to abortion.

One sometimes hears of electrical activity in the fetal brain at an early age, but electrical activity is decidedly not to be equated with a functioning brain when it is considered that one can detect an electrical signal from *any* living cell. At twelve weeks, for instance, when such electrical activity is spotted, the fetus has virtually no connections established in its brain; hence at this point it cannot experience pain or emotions like fear. It is significant in this regard that advances in neonatology since the *Roe v. Wade* Supreme Court decision have primarily consisted of improving the chances of survival in good health of third trimester fetuses. There has not been a corresponding lowering of the age (e.g., to twelve weeks when electrical activity can be detected in an early fetus) when fetal survival in good health outside of the womb can occur.

Nor is it likely that such a lowering will occur in the future, as we will see. The chances of a fetus born at twenty-three weeks surviving in good health, for example, are not better now than they were at the time of *Roe v. Wade* (1973). A fetus removed from the womb before the twenty-fifth week (i.e., before the third trimester) faces numerous problems that make survival unlikely and, given the severe deformities this fetus would probably possess, it is perhaps best that it would not survive. Once again, although the gross outlines of organs appear relatively early in pregnancy, the process of elaboration takes much longer. Survivability (or better, meaningful survivability) or viability is not unconnected to the qualitative difference made by a functioning cerebral cortex. In addition, before the third trimester the lungs, the circulatory system, the kidneys, the skin, et cetera, also fail to reach the threshold at which they can be said to have achieved their operating potential. A fetus becomes a human being in the moral sense of the term at the same approximate point when it acquires the ability to survive outside the womb. To be precise, viability and having a functioning central nervous system are conceptually distinct criteria for moral patiency, but in actual-

ity they come into play at the same time in fetal development, hence it is hard not to think that they are, in practice if not in theory, related.

Some opponents to abortion might object that there is no necessary connection between what we have said regarding the functioning of the central nervous system, especially the brain, and the acquisition of moral patiency status by the fetus. But even if this objection holds (which we deny), it is crucial to note that there is no necessary connection between the moral patiency status of the fetus and fertilization, either. That is, when a fetus becomes human in the sense that it deserves moral respect as a human person is a matter of debate, a debate that should be engaged in with the best available tools human rationality has to offer. If it is true that before the functioning of the cerebral cortex there can be only reaction to stimuli on the part of individual cells, but not sentiency per se, whereby the fetus can experience pain, then contemporary science can help us to amplify Augustine's point to the effect that the fetus early in pregnancy has a (non-) moral status comparable to that of a plant. And we now know that a zygote can be created in a lab independent of its genetic mother. These facts, along with many others, we will argue, should lead us to take seriously Augustine's and Thomas Aquinas's theory that a fetus in the early stages of pregnancy is not a human being in the morally relevant sense of the term; that is, the fetus in the early stages of pregnancy is not a person.

Finally, we would like to make it clear that we do not equate being a moral patient with being a human person. For example, animals are in *some* sense moral patients even though they are not human persons, as we will show in the afterword in terms of the argument from marginal cases. Our view is that: (1) Presentient beings (per se, to be explained later) have no direct moral standing as moral patients, although they may, as in the case of a fuchsia plant, have indirect moral standing as a result of the fact that they are someone's property. (2) Sentient beings (per se), by way of contrast, are moral patients at the very least because it is an obvious moral wrong (we assume) to inflict pain on them unnecessarily or gratuitously. They can be directly harmed be-

cause they are conscious beings who have lives that can go well or ill for *them*, quite apart from their owners' views of the matter.[8] And (3) rational, autonomous beings are both moral patients (who can receive harm) and moral agents (who can intentionally inflict harm), hence only they can be held morally accountable for their actions. Fetal development is intellectually interesting at the very least because the fetus moves from a pre-sentient status to a sentient one, and then develops the real potentiality for, if not the actualization of, rationality and autonomy. To put the matter in Augustinian or Thomistic terms: fetal development consists in the transition from a vegetative state to a sentient one, *after which* (!) it is possible for human ensoulment (or personhood) to occur. In sum: (a) certain physical developments (most notably, a functioning central nervous system) are required for sentiency to occur in a fetus; (b) sentiency is a necessary and sufficient condition for being a moral patient; and (c) along with Augustine and Thomas Aquinas we believe that sentiency is a necessary condition for receiving a human soul.

Cruel Lust:

Saints Augustine

and Thomas Aquinas

THE TWO FIGURES MENTIONED in the title to the present chapter are generally considered to provide the foundation for later Catholic thought on numerous topics, including metaphysical and ethical issues; but, curiously, they have been largely ignored on the topic of abortion. It will be the purpose of this chapter to consider carefully these two thinkers' views of abortion, views that should, we allege, throw into disarray any neat, packaged distinction between orthodoxy and heterodoxy on the abortion issue. And their views are complex enough, we allege, to combat any dogmatism on the part of contemporary Catholics who are in favor of an anti-abortion stance.

Augustine's View

John Noonan hyperbolizes when he says that condemnation of abortion has been "an almost absolute value in history," since, at the very least, the ancient Greeks tolerated abortion, as Paul Carrick details. When, in the Hippocratic Oath, the physician is prohibited from performing abortions, it seems that this prohibition has more to do with defining a physician's area of specialization than it does with a moral respect for the fetus in the early stages of pregnancy; specifically, other specialists were to do the

abortions. Noonan is on safer ground when he suggests that condemnation of abortion is the prevalent view in the history of Catholicism.[1] The question, however, is whether the change from ancient permissiveness regarding abortion to early Catholic condemnation of abortion had more to do with a change in attitude regarding sex or to a change in attitude regarding the moral status of the fetus in the early stages of pregnancy. We will claim that it is the former.

That is, it is important to ask *why* abortion was condemned in Catholicism. At least two quite different responses are given in two articles devoted to the topic. James McCartney clearly states one view:

> Many people believe that the Roman Catholic Church's opposition to abortion stems from its conviction that a new human person exists from the first moment of conception and that this newly formed person has as much right to exist as anyone else. It is clear that this is not now, nor ever been official Church teaching on this matter. . . . Roman Church leadership has sought to maintain, in one form or another, a link between sexual activity and procreation, and thus it follows that even if the fetus were not a human being, Catholics would still view abortion as evil.[2]

McCartney cites many theological supporters, including the Sacred Congregation for the Doctrine of the Faith, which expressly leaves aside the question of the moment when the spiritual soul is infused. The other view is held by Noonan as follows:

> The most fundamental question involved in the long history of thought on abortion is: How do you determine the humanity of a being? To phrase the question that way is to put in comprehensive humanistic terms what the theologians either dealt with as an explicitly theological question under the heading of "ensoulment" or dealt with implicitly in their treatment of abortion. . . . [T]he answer they gave can be analyzed as a refusal to discriminate among human beings on the basis of their varying potentialities. Once conceived, the being was recognized as man because he had man's potential. The criterion of humanity, thus, was simple and all-embracing; if you are conceived by human parents, you are human.[3]

We will call the former view the *perversity* position and the latter view the *ontological* position.

Our purpose in this chapter is not to *prove* that McCartney is correct regarding the claim that the perversity position has always been the official position of the Catholic church, although we do think that he is, in fact, largely correct in this claim. Rather, we would like to explore here the question as to which of these two views is a more useful heuristic to help us understand first Augustine's and then Thomas's view of the moral status of the fetus and abortion. We are not being arbitrary, for most recent scholars on Augustine's view of abortion, for example, agree at least implicitly that these are the views of abortion that must be used to understand him. But we disagree with the way in which some Augustine interpreters have all but admitted that Augustine held the perversity position, while (in an inadvertent way) relying on the ontological position to shore up Augustine's weaker arguments. We claim that whereas Augustine condemned abortion in the later stages of pregnancy on ontological grounds, his condemnation of abortion in the early stages of pregnancy rests *simpliciter* on the view that abortion is a perversion of the true function of sex and marriage. We will examine five texts from Augustine in support of our thesis.

First the interpreters. Because of his admirable boldness,[4] Michael Gorman is the easiest to criticize. Gorman admits that Augustine distinguishes between the unformed and the formed, or the inanimate and the animate, fetus and that for Augustine the destruction of the formed fetus was murder. The destruction of the unformed fetus was not murder, although it was immoral because it denied procreation, which was the purpose of sex and marriage for Augustine. But Gorman also says that Augustine's view of abortion must not be removed from "his struggles to understand the origin of life" and that the "more profound reason for his condemnation of abortion seems to have made him uncomfortable with his distinctions between the formed and the unformed fetus." This "more profound reason" is what we have called the ontological position and it is alleged by Gorman to have reached fruition in Augustine's *Enchiridion,* although (Gorman

adds) Augustine had a "long-held conviction that all human life is 'God's own work.' Faced with human inability to ascertain when the fetus begins to live, Augustine chose to emphasize the value of all [human] life, whether actual or potential."[5]

Noonan and John Connery in effect agree with Gorman, albeit implicitly. Noonan criticizes[6] Constancio Palomo Gonzalez's *El Aborto en San Augustino* for failing to cite any text to support the claim that for Augustine abortion is to be equated with homicide. The distinction in Augustine between aborting an unformed and a formed fetus is acknowledged by Noonan, even if this distinction is not exactly the same as that between the soulless (inanimate) and ensouled (animate) being. What is perplexing is that Noonan agrees with Gonzalez that for Augustine the fetus was ensouled at all stages, and hence that Augustine *should* have called all abortion homicide. Further, Noonan suggests that in Augustine, as in early Christian thinkers in general, embryonic life itself was sacred, presumably because it was human life and not just because it was created by God. In any event, Noonan does not rule out the ontological position.

Nor does Connery.[7] He notes that condemnations of abortion in Augustine's age were mostly against those who resorted to abortion after fornication or adultery, a position that implies the perversity rather than the ontological view. The unformed-formed, inanimate-animate (i.e., the soulless-ensouled) distinctions also receive their due. But Connery emphasizes a passage in the *Enchiridion* where Augustine finds it rash to maintain that the fetus is not alive (presumably with human life) the whole time it is in the womb. And Connery claims that for Augustine (in his commentary on the Septuagint) it is possible that the unformed fetus nonetheless is animated with a soul. In short, like the other two interpreters, Connery complicates the perversity position by adding the ontological one. It seems to us that Ockham's razor can be fruitfully used on the beard of the ontological position when dealing with the fetus in the early stages of pregnancy. In support of this thesis, we will now examine some texts from Augustine himself.

a. Augustine's position on sex is quite forcefully put in his

work *On Marriage and Concupiscence* (*De Nuptiis et Concupiscentia*, I, 17).[8] Married persons who have intercourse only (*sola*) for the wish to beget children do not sin, whereas those who mix pleasure with sex, *even if* sex with one's spouse, commit sin. A remarkable view! It must be granted that this sin is venial (i.e., *venia* or pardonable), but the mere fact that it is a sin at all should alert us to how negative Augustine's view of sex is. Even worse than intending pleasure in sex is to try to prevent pregnancy, say through an evil appliance (*opere malo*), or, we might add, through the "rhythm method." For Augustine those who use such contraceptive devices retain no vestige of true matrimony, which is synonymous with, not accidentally connected to, propagation. These people sometimes (*aliquando*) go so far as to have abortions in their lustful cruelty (*libidinosa crudelitas*). Since Augustine also accuses those who have merely used contraceptive devices of being cruel, we can be sure that it is not cruelty to a human person inside the womb that he is worried about. It is Augustine's own clever pen that makes this clear when he rephrases his accusation as cruel lust (*libido crudelis*). Lust itself (or even the *desire* for sexual pleasure) is cruel, whether or not a fetus is aborted.

If an abortion takes place, however, Augustine is careful to distinguish between a conceived seed (*conceptos fetus*) that has not yet received vitality (*prius interire quam vivere*) and that which has, and to distinguish between that which was advancing toward (human) life in the womb (*aut si in utero jam vivebat*) and the newborn infant. The point to Augustine's use of these distinctions is not to claim that all or even some abortions are examples of murder, but rather that all abortions *and* all attempts at contraception are examples of cruel lust or harlotry or adultery. Both here and elsewhere in *On Marriage and Concupiscence*, Augustine indicates that sex is a necessary evil; it is necessary, that is, for having children.

b. Reading present ideas into the thought of past thinkers is perhaps the greatest danger faced by any historian of ideas. For defenders of the current animus in Catholicism against abortion, this danger often surfaces in the attempt to take the relatively

recent practical abolition of the distinction between (to use Augustine's terms) the inanimate and the animate fetus as normative for the whole history of Catholic thought. Connery correctly notes that this abolition, which occurred in 1869, was made in order to make penalties, *not* to constitute church theory or teaching. However, Connery alleges that in Augustine's *Against Julian (Contra Julianum Pelagianum*, VI, 14, 43),[9] the status of the fetus is clarified, because Augustine indicates that when "the child is conceived" it is subject to original sin; hence, Connery thinks, "the fetus" is not part of the mother "while it is in the womb."[10]

It is difficult to understand Connery's point here. What Augustine says is that all children of the concupiscence of the flesh (*omnes filios concupiscentiae carnalis*) come under a heavy yoke of the children of Adam; no mention is made of *when* they become children, nor is conception mentioned. Further, Augustine indicates that if a mother who is in danger of death is baptized and the *infant* in her womb is also (*cum etiam*) baptized, there is no need to baptize it again outside the womb. But this is not evidence that Augustine is talking about a recently conceived fetus; indeed he calls the being in question an infant (*infans*), which, given the evidence from other texts, obviously refers to a formed, animated fetus.

c. Our interpretation of (b) is buttressed not only by our claims regarding (a) but also by a consideration of a passage in *The City of God (De Civitate Dei*, XXII, 13).[11] Here Augustine asks whether aborted fetuses will have a part in the resurrection. Both Noonan and Connery notice that Augustine is inclined to be in favor of their resurrection, but the positions of these interpreters need precision. Augustine does not deny that these fetuses will be resurrected, but he does not make any positive claims on the topic *even if* the fetus in question is alive in the mother's womb (*Abortivos fetus, qui, cum jam vixissent in utero*), a fetus developed to the point that Augustine compares it to an infant (*infantibus*). Because Augustine is tentative *even* with respect to the developed fetus, mentioned here as well as in *On Marriage and Concupiscence*, it is understandable why he does

not even consider the possibility of the resurrection of the un-
developed fetus.

d. In the *Enchiridion* (*Enchiridion, Sive de Fide, Spe et Chari-
tate*, 85–86),[12] Augustine does make an attempt to consider the
possibility that aborted fetuses (*abortivis fetibus*) that were not
fully formed (*de iis qui jam formati sunt*) might be born again.
It is perhaps because Augustine considers this *possibility* in the
Enchiridion, but not in *The City of God*, that Gorman sees him
making progress in this work. But *if* there will be a resurrection
for these fetuses—not even in this passage does Augustine affirm
that there will be a resurrection for unformed fetuses—it could
occur *only if* the defect in form were remedied in such a way that
the fetuses' incomplete states were completed. None of these
speculations on Augustine's part, however, are to be taken to
mean that *present* unformed, incomplete fetuses are human per-
sons. He rhetorically asks, "Now who is there that is not rather
disposed to think that unformed abortions (*informes vero abor-
tus*) perish like seeds that have never been fructified (*sicut
semina quae concepta non fuerint*)?"

Augustine is explicit that he does not know (*ignoro*) when the
human infant begins to live in the womb (*quando incipiat homo
in utero vivere*), nor if human life exists in a latent state (*utrum
sit quaedam vita et occulta*) before that point. It is audacious
(*impudentia*) to think that the fetus could not be human if it were
torn out from the womb limb from limb (*membratim*). But this
reference to limbs certainly indicates that Augustine is think-
ing here of a highly developed fetus. As in *The City of God*, it is
only after the fetus begins to live as a human (*incipit homo vive-
re*) that resurrection is taken as a serious possibility.

e. It is by no means obvious that the ontological view is strength-
ened, as Connery alleges, in Augustine's commentary on the Sep-
tuagint (*Quaestionum S. Augustini in Heptateuchum*, II, 80).[13]
It must be admitted that there is no fixed set of terms that Au-
gustine uses to make the distinctions he wants to make re-
garding the fetus. Sometimes he talks in terms of the difference
between the unliving and living (*vivere* and its cognates) fetus
(i.e., living as a human being—*homo*, etc.), sometimes in terms

of the unformed and formed (*forma*, etc.) fetus, and at other times in terms of the inanimate and animate fetus (i.e., animated by a soul—*anima*, etc.). But some such distinction is found in all of the texts we have examined. Here Augustine considers the possibility that the unformed fetus could nonetheless be animated. Characteristically, however, Augustine says that this is too large a question to answer, hence the inadequacy of Noonan's view that "the criterion of humanity . . . was simple." Augustine is abundantly clear, and repeats his point several times, that the pregnant woman who has an abortion is *not* to be accused of murder (*ne praegnans mulier percussa in abortum compelleretur*) because the question of homicide is not even pertinent with respect to the unformed fetus (*Quod vero non formatum puerperium noluit ad homicidium pertinere. . . . et ideo non sit homicidium. . . . ideo Lex noluit ad homicidium pertinere*).[14] Our conclusion is that Augustine's opposition to abortion of an unformed fetus is based on the perversity view, not the ontological one.

It must also be admitted that Augustine does not have a developed theory of the succession of souls (from a vegetative to a sentient to a rational state) such as we find in Thomas Aquinas.[15] But Connery is premature in dismissing a theory regarding the succession of souls in Augustine altogether, especially because of the Stoic transmission of the Aristotelian theory of succession of souls to the Church Fathers. We have previously seen that Augustine refers to the unformed fetus as a seed (*semina*), and here in his commentary on the Septuagint vegetative metaphors abound, as, for example, when he claims that a human being is not destroyed when a cutting is clipped from a sprout *in utero* (see also his use of *tale*—a cutting, *deputo*—to prune, and *germen*—a sprout). Indeed, the word *fetus* itself has vegetative connotations, as does abortion, which comes from *abortus*, the suppression of the fruit of the body. Further, just as these vegetative metaphors refer to a fetal stage preliminary to the existence of human personhood, Augustine also indicates that sentiency is a necessary condition for a human person to be present in the womb; hence only eventually, in later stages of

pregnancy, is abortion homicide. It is difficult for Augustine to imagine how there could possibly be animation without the fetus at least having sensation (*quia nondum dici potest anima viva in eo corpore quod sensu caret, si talis est in carne nondum formata, et ideo nondum sensibus praedita*).[16]

Even vegetative matter is a wondrous creation on the part of an omnibenevolent God, and the wonder is increased by present human knowledge of botany and photosynthesis. But vegetation has no *moral* status in the Catholic tradition. A rose bush is neither a moral agent (since it lacks rationality) nor a moral patient (since it lacks sentiency per se, to be defined later in the book). Hence, Augustine's repeated descriptions of the fetus in the early stages of pregnancy in vegetative terms, and his repeated denial of the view that abortion in the early stages of pregnancy is homicide, provide the bases on which a contemporary Catholic pro-choice stance regarding abortion can be built. As we saw in the introduction, our best available scientific understanding of the development of sentiency per se in the fetus locates it, along with the functioning of a central nervous system, rather late in pregnancy, so that the fetus before the third trimester can legitimately be described in Augustinian (i.e., vegetative) terms.

To summarize, we think it is fair to say that Donceel's argument, to be treated momentarily, that abortion in the early stages of pregnancy can be morally permissible on Thomistic grounds would also apply to Augustine. This argument would be inapplicable only if Augustine is correct regarding the perversity of all sex not within the confines of marriage *and* not with the sole (*sola*) intent of having children.[17] We have not objected to the general attempts of Gorman, Noonan, and Connery to use the history of ideas in order to serve the purposes of contemporary Christian life, but we have objected to their particular interpretations of Augustine. We would also object if someone were to suggest that her appropriation of Augustine's view of abortion is the only possible one. That is, our thesis in this section of the chapter gives at least indirect support to those like Maguire who have voiced the opinion that there are a plurality of Catholic views of abortion.

Thomas Aquinas's View

Although Thomas was apparently less interested than Augustine in the topic of abortion (nowhere in the *Summa Theologiae* is there an article on abortion, and he seldom talks about the topic elsewhere), and this presumably because abortions were not as prevalent in his day as they were in Augustine's at the end of the Roman Empire, he was more interested than Augustine in the ontological status of the fetus in the early stages of pregnancy. It is to Thomas that we will now turn, with Donceel as our guide.

We should all agree with a basic principle in Thomas, and in Catholicism generally, that we ought not to knowingly kill innocent human persons. (Elsewhere one of us has defended Christian pacifism largely on the basis of this very Thomistic principle: *et ideo nullo modo licet occidere innocentum*—there is, therefore, simply no justification for taking the life of an innocent person[18]—although we now add that an innocent person can be said to legitimately waive his or her right not to be killed.) It is for this reason that we should get clear regarding the question of whether there is a real human person from the "moment" of conception; if there is, then abortion may very well be seriously immoral even in the early stages of pregnancy. The current majority Catholic opinion seems to be that there is a real human person from the first moment of conception, or at least that we cannot be sure that this is not the case. But the current minority opinion, shared by Augustine and Thomas, is, it seems (according to Andrew Greeley), slowly gaining favor among Catholic thinkers: there is no human person during the early stages of pregnancy.

The traditional Catholic view, as Donceel more than anyone has emphasized, is that what makes an organism a human person is a rational or spiritual soul that is "infused" into the body by God. If this occurs at the moment of conception, the theory of *immediate hominization* is correct; but if a human soul is infused into the body only at some later stage, for example, when the latter begins to show a human shape or outline and possesses the basic organs (especially a central nervous system), then the

theory of *mediate or delayed hominization* is correct. Before hominization the embryo is alive, but only in the way in which a plant or, at best, an animal is alive.

Thomas held the delayed hominization view because of his hylomorphism, where the human soul is the form of the human being. That is, the human soul is to the body (*hylē*) like the shape or form (*morphē*) of a statue is to the actual statue—to use Donceel's somewhat helpful but also somewhat misleading example, since a statue is too static to adequately model the organic development of a fetus. The shape of the statue cannot antedate the actual statue, since the sculptor can only conceptually, but not physically, first make the shape and then introduce it into a block of marble. Thomas knew that whatever was growing in the mother's womb early in pregnancy was not yet a real human body; hence, it could not be animated by a human soul any more than a square block of marble can already possess a human shape.[19] At most, we can only say that the fetus in the early stages of pregnancy is potentially a human body. And it is worth noting, as we will see, that the hylomorphic conception of human nature was officially adopted by the Catholic church at the Council of Vienne in 1312, and that for centuries the church forbade baptizing any premature births.

An instructive slogan from Donceel that well summarizes Thomas's view regarding the fetus is "immediate animation and delayed hominization." Although the terminology is more refined in Thomas, Thomas ends up with basically the same view as that of Augustine. For Thomas, animation means that the organism is animated or has a soul (*anima*), and hence is alive. The fetus is animated from the very start in Thomas, as it is in Augustine and in Aristotle.[20] First it is animated by a vegetative or a nutritive soul (*anima vegetabilis*), then by a sensitive or an animal soul (*anima sensitiva*), finally by a rational or human soul (*anima intellectiva*).

It must be admitted that, as a general rule, the Greek Fathers (e.g., Gregory of Nyssa) held a theory not only of immediate animation but also of immediate hominization. But even among the Greek Fathers, there were those like Theodoret who defended

delayed hominization, a view that dominates among the Latin Fathers. One of the Latin Fathers who sometimes (but not always) defended immediate hominization, however, was Tertullian, whose position was based on the Traducian ground that the human soul of a fetus derived directly from its parents, a view vigorously criticized by the other Latin Fathers, who thought that hominization was directly caused by God. The list of Latin Fathers and scholastics who supported delayed hominization is too long to document here, but it includes not only Augustine and Thomas but also St. Anselm and Hugh of St. Victor, among others.[21]

The key point, from Thomas's point of view, is that it is only the final, the human, soul that comes from the outside, from God. But the soul can only be a *human* soul if it animates a human body; rationality presupposes sensation and sensation presupposes sense organs. The fetus originally has these sense organs only potentially and acquires them only gradually: rational souls are not engendered through coitus (*animae rationales non seminantur per coitum*).[22] Rather, for Thomas, body and soul organically grow together until the body is disposed to receive a human form. To hold that a human soul existed right from the beginning (*a principio*) would be to hold that human persons were, in effect, disembodied angels (*angelis*) rather than human beings. (Angels are disembodied if not entirely immaterial.) Thomas quite adamantly rejects the dualist view that the soul *is* the man or woman and that it is connected to the body only accidentally or incidentally. The human (as opposed to the angelic) soul "*needs* to be joined to a body, for it needs the latter for the functioning of the sense faculty" (*Et ideo indiget uniri corpori, quo indiget ad operationem sensitivae partis*).[23]

A human soul is the act of an organic body for Thomas, but this human soul cannot function until the powers of nutrition and growth, which are its auxiliaries, have completed their work. That is, there are intermediate forms between the first elemental form (*primam formam elementi*) of the fetus and the ultimate, human form in a process that is largely, but not entirely, continuous (*non enim est tota alteratio continua*).[24] A summary of

Thomas's view is given in the *Summa Contra Gentiles*: "Thus, the vegetative soul, which is present first (when the embryo lives the life of a plant), perishes, and is succeeded by a more perfect soul, both nutritive and sensitive in character, and then the embryo lives an animal life; and when this passes away it is succeeded by the rational soul introduced from without, while the preceding souls existed in virtue of the semen."[25] As before, a human person is not a body or a soul alone, but is rather a hylomorph. There is a natural fit between the human soul and its body such that the former is incomplete without the latter. In fact, the human soul is so essentially linked to its body, according to Thomas, that it must get the *same* body back for *personal* resurrection to occur.

The disposition of the rational soul is in keeping with the disposition of the body because it receives something significant from the body, contra what Thomas sees as the inadequacies of Gregory of Nyssa's theory of immediate hominization. Gregory's is a Platonic view that anticipates, as we will see in the next chapter, the Cartesian stance popular in the seventeenth century, where a human person is not a besouled body but a soul making use of a body. Further, this is a stance that, if true, would be perfectly consistent with, and may actually entail, the preexistence of soul and the transmigration of soul from body to body—beliefs that are obviously not Catholic ones. And if this stance were correct, Thomas notes, there would be no reasonable cause for the soul to be unified with *this* body, a body that, on the Platonic view, is only accidentally connected to soul.[26]

Our primary goal in this chapter has been to argue that neither Augustine nor Thomas thought of the fetus in the early stages of pregnancy as a human person, so that neither could have opposed early abortions due to the ontological position. Augustine makes it clear that he is opposed to abortion, but on perversity grounds: it is a sign of "cruel lust," as mentioned above. We can assume that Thomas was also opposed to abortion on perversity grounds, but it should be noticed that he hardly ever talks about abortion. Given his extensive treatments of various moral issues, this paucity is significant, we think. Our overall point

regarding Thomas, however, has been that if he was opposed to abortion at all stages of pregnancy, it could not have been an opposition based on the ontological view because his dynamic hylomorphism makes it impossible for a fetus in the early stages of pregnancy to be viewed as a human person, a status that can only occur when the fetus becomes sentient. We will later argue that sentiency is a necessary and sufficient condition for moral patiency status, and (in keeping with the thought of Augustine and Thomas Aquinas) a necessary condition for human personhood.

A final remark on an important difference between Augustine and Thomas is needed. Despite the fact that (through the influence on him of the Stoics) Augustine is an Aristotelian regarding fetal development, he is generally more of a Platonist than is Thomas.[27] It is Augustine's greater sympathy for dualism that makes him more negative with regard to human sexuality, in particular, and more negative with regard to the human body, in general, than is Thomas. And it is precisely Thomas's dynamic hylomorphism that enables him not merely to tolerate the body but, for lack of a better word, to treat it sacramentally. It would be appropriate for one who understands well Thomas's dynamic hylomorphism to let one's mind descend into one's body and treat it with ever increasing respect.[28] We will see in a later chapter that the full implications of this positive, dynamic hylomorphic view of the body were not always adhered to by Thomas himself, nor always by his followers. That is, like Columbus, who made a great discovery but mistook what it was that he had discovered, Thomas brilliantly laid the basis in his dynamic hylomorphism for a sexual ethics far more positive than Augustine's, and far more compatible with the view of sexual relations as morally permissible to the extent that they involve both mutual consent and mutual (agapic) respect.

It should now be clear that there are sufficient grounds for calling into question the claim of Richard McCormick that "the traditional Christian view on abortion . . . was that the fetus was inviolable from the moment of conception."[29] Nonetheless we can learn from McCormick that a spirit of civility is necessary

in the abortion debate, so that, at the end of the day, we will not say, in reference to that debate, "when all is shrieked and done."

What we hope for in the present book is the initiation of a constructive dialogue with those like Beverly Whelton who identify hominization with DNA activation, which occurs at approximately fifty hours after sperm entry. Surprisingly she argues for this view on what she sees as the Aristotelian or Thomistic idea that substantial change has occurred when a new being has its own (genetic) principle of activity and rest. Whatever the merits of this view, which we discuss later in the book, it is certainly not the only way (as Whelton seems to think), nor the most plausible way, to understand Thomistic dynamic hylomorphism. Further, Whelton stretches matters quite a bit when, in response to Donceel, she seems to locate a functioning cerebral cortex as early as eight weeks of pregnancy. Whatever Thomas's own views were regarding when the fetus became sentient (given the biological knowledge he had to work with), we nonetheless think that he made the correct metaphysical point: sentiency (not mere DNA activation) is a necessary condition for the reception of a rational soul.[30]

The Influence of the Seventeenth Century

WE HAVE SEEN THAT THE popular view of the Catholic stance on abortion is too simple. Abortion, it is thought, is considered wrong by Catholic thinkers because the fetus is, from the "moment" of conception, a human person. Many Catholic leaders and thinkers have encouraged this overly simple view. But those who have studied the matter carefully know that abortion is a complex issue within the history of Catholic thought. The purpose of this chapter is to use the thought of Fathers E. C. Messenger, Henry de Dorlodot, and Joseph Donceel both to highlight this complexity and to claim that the stance of the church at present seems to be based on certain mistakes made in seventeenth-century science. We will also compare our view to that of Thomas Shannon and Allan Wolter, O.F.M.

We have seen that philosophical opposition to abortion within Catholicism has been of two sorts: (1) The ontological view is the one mentioned above regarding the ontological status of the fetus as a human person from the "moment" of conception. To kill the fetus, even in the early stages of pregnancy, is, on this view, either murder or something closely approximating murder. (2) The perversity view, however, prohibits abortion regardless of whether the fetus is, in the early stages of pregnancy, a human person worthy of moral respect. On this view the sole purpose

of sex (or at least the prime purpose of sex, if conjugal love is also considered) is to have children within marriage, so that to abort a fetus in the early stages of pregnancy, even if the fetus is not a human person worthy of moral respect, is a perversion of the true purpose of sex.

Contemporary opponents of abortion within Catholicism thus face a philosophical problem. If they hold the perversity view—the traditional view of Augustine and, presumably, of Thomas—they should be morally opposed not only to abortion but also to contraception, premarital sex, postmenopausal sex, homosexual sex, heterosexual sex between married partners at a time of the month when at least one of the partners knows that conception is unlikely, and sex within marriage when one of the partners is sterile. Augustine himself would have thought that all of these are examples of immoral sex; even a married couple that has sex for the sake of mutual pleasure sins, albeit in a venial way.[1] It is significant that *very* few contemporary Catholics are as consistent in their defense of the perversity view as was Augustine. This is because it is, to say the least, counterintuitive to most contemporary people—including most Catholics—that married people should feel guilty if they have sex for some reason other than to attempt procreation.

However, if the contemporary opponent to abortion wishes to defend the ontological view, it will most likely be on some nontraditional basis, specifically on some version of seventeenth-century science or metaphysics. That is, most contemporary opponents to abortion in Catholicism seem to be Cartesians in spite of themselves. Augustine (through the mediation of the Stoics) and Thomas, as we have argued, both adopted the Aristotelian view that the soul and the body of the fetus *organically develop together,* so that the fetus moves from a vegetative to a sentient state and then to a state where it has the real potential for rationality. It was not until the seventeenth century, as we will see, that the view was defended in Western Christianity that a human soul worthy of as much respect as a rational adult could appear instantaneously in a microscopic speck of matter. This view is Cartesian, as Donceel emphasizes, in that on this con-

ception soul and body are radically different from each other and do not organically develop together. Aristotle, Augustine, and Thomas would, we think, find it silly to think that, from a moral point of view, one could have a fully developed soul in a largely unformed body, much less in a fertilized ovum.

In short, the perversity view, which was perhaps seen as convincing by Thomas and especially by Augustine, strikes few people, not even very many Catholics, as convincing today; and the ontological view, which is rather popular, is not the traditional Catholic view, but rather seems to rest, as we will see, on certain seventeenth-century mistakes. The present chapter is intended in part to deal with the following very interesting problem: how to account for the preponderance of thinkers who opposed abortion on perversity grounds, and the paucity of those who opposed it on ontological grounds, throughout the first sixteen hundred years or so of Western Christianity, and how to account for the reverse emphasis in recent times. Our thesis is that this transition, which started in the seventeenth century with Thomas Fienus, Pierre Gassendi, Jerome Florentine, and others, and which was nearly complete by the end of the nineteenth century, cannot be understood without considering the concomitant history of embryology.

The Seventeenth Century

We should begin by asserting the inapplicability of divine command theory to the problem. Our problems are not the same as those faced by Jews and Christians centuries ago, so it is not odd that the Scriptures pass by in silence moral issues that seem urgent to us. And as useful as biblical precepts may be, they do not necessarily yield definite answers to specific contemporary problems such as abortion. Nonetheless, there is a common pattern exhibited by certain religious believers regarding moral issues. Christian tradition, in general, and Catholic tradition, in particular, may be ambiguous about a specific issue; but zealous or dogmatic individuals feel so strongly about the issue that they only notice those elements that support their side, so that it is easy

for them to conclude that Christianity, in general, or Catholicism, in particular, mandates their favored moral view. These individuals only notice what they want to notice within the tradition because they have *already* made up their minds about the issue and then look to Scripture or tradition for support.

Such a pattern can easily be seen in contemporary opposition to abortion. The key premise in this opposition is that the fetus is a human person worthy of moral respect from the "moment" of conception. The fertilized ovum is not merely a potential human person, as Augustine and Thomas thought, but an actual human person with a full-blown right to life. Where is the support for this key premise? No clear evidence comes from the Bible. For example, a frequently cited passage from the first chapter of Jeremiah ("Before I formed you in the womb I knew you") is, in context, obviously not meant to deal with the issue of abortion, but with God's intention to make Jeremiah a prophet before Jeremiah was aware of this fact. The issue is complicated even more when the twenty-first chapter of Exodus is considered, where we learn that the penalty for murder is death, but the penalty for causing a pregnant woman to have a miscarriage is only a fine, and that to be paid to the husband. The ancient Israelites, like Augustine and Thomas, viewed the fetus, at least in the early stages of pregnancy, as something less than a full human person.

There is something arrogant in assuming that God *must* share one's own moral opinion, especially if one's moral opinion is based on a scientific view that has been discredited. Messenger, de Dorlodot, and Donceel, by way of contrast, are correct to have us note that Thomas's dynamic hylomorphic view of fetal development was officially accepted by the church at the Council of Vienne in the fourteenth century and has never been officially repudiated.[2] However, in the seventeenth century, a strange view of fetal development began to be accepted, and this had serious consequences for the Catholic view of abortion. Looking through magnifying glasses and primitive microscopes at fertilized eggs, some scientists imagined that they saw tiny, fully formed animal fetuses. In the case of human fetuses, they called the little

person a "homunculus," and the idea took that from the very beginning the human embryo is a fully developed creature that needs only to get bigger until birth. Some within the church began to reason as follows: *if* the embryo has a human form from the moment of conception, then on good Augustinian or Thomistic grounds it can have a human soul from the moment of conception as well. Hence, it is morally wrong to kill the homunculus.

As understanding of biology progressed, however, scientists came to realize that this view of fetal development was mistaken. There just is no homunculus, and Augustine's and Thomas's original assumption was correct: fetuses start out as what we today would call a single cell, then as a cluster of cells; human form comes later. Messenger's, de Dorlodot's, and Donceel's genius lies in seeing that there is a major problem here. When the error in seventeenth-century biology was corrected, the church's moral view unfortunately did not return to the older, more consistent, Augustinian and Thomistic position. Having adopted the theory that the fetus is a human person from the "moment" of conception, the church did not let it go and held fast to the view of abortion that seems to have arisen as a result of erroneous seventeenth-century science. The Council of Vienne notwithstanding, it has held that view to this day. *Because* the church did not traditionally see abortion, at least in the early stages of pregnancy, as murder, Western law did not traditionally treat abortion as a crime. Under English common law abortion was tolerated, even if performed late in pregnancy. And in the United States there were no laws prohibiting abortion until the nineteenth century. The *Roe v. Wade* decision did not so much overturn a long tradition of moral and legal opinion as it restored the moral and legal situation that had existed until recently: abortion, at least in the early stages of pregnancy, is not murder or anything closely approximating murder. Abortion may be a perversion of what sex should be about (although we will criticize this view later), but ontologically speaking it is more like pruning one's rose bush (to use Augustine's language) than acting like a murderer.

It is not our purpose to claim that the Catholic church's present

position on abortion is irrational or wrong *simpliciter*. Rather, it is to suggest, minimally, that Catholic tradition on abortion is complicated enough that one cannot invoke this tradition in a noncontroversial way to support contemporary (ontological) opposition to abortion. And, maximally, we are trying to defend the view that contemporary opposition to abortion founded on the ontological view is implausible when it is noticed that it seems to be based on certain seventeenth-century mistakes. It is to these mistakes that we wish to turn.[3]

The scientific theory that supported the aforementioned belief in a homunculus was preformationism, a theory which asserted that each organism starts off with all of its parts already formed. Development (literally, emergence from envelopes) of an organism therefore merely consists in its getting bigger. Several factors aided the preformationist theory, the first of which is obvious: the invention of the microscope, which not only supplemented the use of the magnifying glass in embryology but also encouraged an overly active use of scientific imagination. That is, the use to which the microscope was put was defective. For example, "observations" by scientists such as Marcello Malpighi (1628–94) indicated that the "rudiments" of the chicken are already in the egg, that is, in the egg is a miniature chicken. Further, several seventeenth-century scientists thought that all future generations of human beings were already present in Eve's ovaries, with the emergence of new people being like the opening of a long series of Chinese boxes.[4]

Another factor that aided preformationism was the theory of ovism, the view that all organisms develop from eggs. No less a figure than William Harvey (1578–1657) declared that an egg is the common origin of all animals. In point of fact, ovism was an advance over the view it replaced that different types of creatures are generated in radically different ways, for example, that insects spontaneously generate from rotten meat. Ovism, by way of contrast, provided a unified theory of generation, and it seemed to support preformationism in that it permitted Malpighi's results regarding plants and silkworms and chickens to be generalized. If all organisms have a common origin in eggs, and if we can see

tiny chickens in chicken eggs, then we can reasonably expect similar phenomena in the eggs of other species.[5]

Ovism did not last very long, however. In 1677 Anton Leeuwenhoek first observed spermatozoa, and he realized that the female egg alone could not be the source of the human embryo. Further, Niklaas Hartsoeker (1656–1725) calculated that if all human beings were contained in Eve, in Chinese box fashion, then the egg in her ovaries would have to have been immensely larger than present-day eggs. The abandonment of ovism, however, did not immediately lead to the abandonment of preformationism. Ovism was replaced by animalculism, a reverse-image of ovism: the egg is nothing but food for the developing organism, which is contained entirely in the male sperm. Hartsoeker became an enthusiast for animalculism, and drew a picture of a fully formed infant curled up inside a spermatozoon (see figure 1).

What finally killed preformationist belief in a homunculus was the realization that organisms inherit characteristics from both parents. Yet it was preformationism and belief in a homunculus that seems to have led both to a stricter opposition to abortion by the church and to opposition to abortion on ontological rather than on perversity grounds. It was because preformationism was believed to be true, and believed to be true on "modern" scientific grounds, that it became popular to think that to kill a fetus in the early stages of pregnancy was to kill a tiny, perfectly formed human being.

It should be emphasized that the shift from belief in delayed hominization to belief in immediate hominization was not abrupt, so that there is no single event to which we can point to account for this change. But the fact that there was a major change in emphasis concerning the ontological status of the early fetus is undeniable. The Council of Trent in the sixteenth century, for example, makes it clear that no human embryo could be informed with a human soul except after a certain period of time, as in the hylomorphic commonplace. But by 1869, with the doctrine of Mary's Immaculate Conception, and 1917, with the new Code of Canon Law, the distinction between the unformed and the formed fetus was no longer canonically recognized. The

Figure 1. Hartsoeker's view of how a homunculus ought to look in the sperm. From *Essai de dioptrique,* 1694.

question is: how can one account for this change? An answer to this question is crucial if one wishes to revive delayed hominization in the contemporary period; in fact, Messenger holds a stronger view of delayed hominization than ours when he says that it is the *only* theory consistent with the facts of modern science.

Or again, what do we know about the period between the late sixteenth century and the nineteenth century that can help us to understand the major changes that occurred in the church regarding the ontological status of the early fetus? We know that the founder of modern atomism, and dedicated opponent to Aristotelian philosophy, Pierre Gassendi (1592–1655), the famous theologian-scientist and Catholic priest, was one of the first modern thinkers to defend immediate hominization; he thought that by twelve days (and perhaps earlier) the fetus was properly organized and formed, from head to toes. We also know that Thomas Fienus, the celebrated doctor of Antwerp, published three works from 1620 to 1629 at the Catholic university at Louvain defending immediate hominization; a fetus was fully human, he thought, by three days. In 1661 a Roman doctor named Paul Zacchias, personal physician to Pope Innocent X, argued in *Quaestiones medico-legales* that a human soul was present from the first moment. And Riolanus, a French scientist who was a contemporary of Harvey, defended nearly immediate hominization.

It is not the purpose of this book to do detailed research in the history of seventeenth-century science. What is clear about this period, however, is that various scientists, theologians, and philosophers adopted immediate hominization, and that those who did so thought their belief to be supported by the latest scientific evidence. That is, immediate hominization was part of the seventeenth-century zeitgeist the way evolution was part of the nineteenth-century zeitgeist. In both cases there were many cross-fertilizations of ideas, influences of one thinker's work on another's, and mutual borrowings. The overall effect of this zeitgeist was a radical altering of the received view of the early fetus. And this altering eventually changed the way many people viewed abortion.

Scientists (including Harvey) eventually moved away from any sort of preformationism, but theologians developed an attachment to preformationism and immediate hominization. For example, in 1658 the theologian and Servite priest Jerome Florentine declared in *De hominibus dubiis sive de baptismo abortivorum* that it was probable that the rational soul was infused immediately after conception, hence fertilized eggs should be baptized if they are in danger of perishing. This book was reported to the Congregation of the Index in Rome, but only minor changes were required. That is, the key point in Florentine regarding the ontological status of the fetus as a human person in the early stages of pregnancy was not declared heterodox. The "facts" associated with immediate hominization were seen, by the mid-eighteenth century, as "absolutely established," according to de Dorlodot. In 1758 F. E. Cangiamila, in his *Embryologia Sacra* (chap. 11 of book 1), offered what was assumed by many to be a definitive version of immediate, or near immediate, hominization.[6]

Preformationism is now a historical curiosity. We now think that fetuses develop from fertilized ova that are single cells, and are not like fully formed human beings. Contemporary opponents to abortion who base their position on the ontological view have tried to replace the preformationist theory with the view that, although fetuses in the early stages of pregnancy do not look or act like fully formed humans, they do contain human genetic material. But this newer version of preformationism is problematic both because: (1) it does not seem sufficient in itself, as did belief in a homunculus, to establish the case that a single cell or a small cluster of cells *is* a human person rather than a potential human person; and (2) it does not trump other views of abortion that also appeal to contemporary scientific evidence. For example, our current knowledge (codified, say, in textbooks used in medical schools) that a central nervous *system* does not begin to function in the fetus until the third trimester—after the period when most abortions are performed—lends support to Augustine's and Thomas's belief that it is only the *developed* fetus that acquires sentiency and, hence, moral patiency status.

We can summarize the argument of this chapter thus far in the

following eight steps: (1) We have referred to the view, detailed in chapter 1, yet to be refuted, that shows that neither Augustine nor Thomas believed that the fetus in the early stages of pregnancy is a human person. (2) However, Augustine's and perhaps Thomas's perversity view is disbelieved by almost everyone these days, including most Catholics. (3) Hence most contemporary opponents to abortion base their opposition on the ontological view. (4) But the ontological view seems to be rooted in seventeenth-century preformationism, a theory that has been thoroughly discredited. (5) Contemporary efforts to prop up preformationism (say through appeal to evidence from genetics) are not more persuasive than the efforts of those who would permit abortion in the early stages of pregnancy (say through appeal to the *eventual* development of a central nervous system in the fetus). (6) The latter efforts to use contemporary science are more compatible with the views of Augustine and Thomas than the former efforts. (7) Hence, as a consequence of (1) through (6), the moral permissibility of abortion in the early stages of pregnancy is, *at the very least*, an intellectually respectable view when the history of Catholic thought on abortion is considered in its relation to the history of science. (8) Finally, it is somewhat embarrassing that there are relatively few Catholics who have attempted to think through the conflict between Augustine's and Thomas's rejection of the ontological view, on the one hand, and the warm embrace of this view by many contemporary Catholic thinkers, on the other. Between these two opposed stances lie some key mistakes in seventeenth-century science.[7]

Shannon and Wolter

Two scholars who present a view *somewhat* similar to ours are Thomas Shannon and Allan Wolter.[8] (Lisa Sowle Cahill does an excellent job of summarizing recent Catholic treatments of abortion, putting Shannon and Wolter in perspective.)[9] Shannon and Wolter emphasize the fact that the widespread acceptance of the theory of immediate animation (or more precisely, the theory of immediate hominization, since even Donceel agrees that the

fetus in the early stages of pregnancy is animated, but not with a human soul) is of post-Tridentine origin, having entered into the tradition only in the seventeenth century. It is ironic that over forty years ago two learned priests from Louvain—E. C. Messenger and Henry de Dorlodot—repudiated the scientific standing of immediate hominization and went to great lengths to explain historically how this mistaken interpretation of empirical data was accepted.[10] The irony lies in the fact that it was at Louvain where Thomas Fienus was one of the first, if not the first, to introduce immediate hominization into modern Catholicism. De Dorlodot, in particular, relies on the Council of Vienne. The seventeenth-century locus of immediate hominization needs emphasis because of the continued reliance in Catholicism on ontological opposition to abortion. And Shannon and Wolter rightly claim, along with Messenger, de Dorlodot, and Donceel, that any theory of immediate hominization is now untenable. However, despite the fact that Shannon and Wolter see the biological data that supported immediate hominization as inadequate, they nonetheless curiously keep open the possibility that previous theologians appropriately interpreted the data from a moral point of view.[11]

Shannon and Wolter rightly note that fertilization is a *process* that takes between twelve and twenty-four hours to complete. They also note that the pre-embryonic zygote does not possess sufficient actualization of its genetic information within its chromosomes to develop into an embryo: further essential and supplementary development of genetic information, including the use of maternal RNA, is required for the zygote to become an embryo around the third week of pregnancy. Moreover, Shannon and Wolter correctly note that the development of the central nervous system is "critical" from a moral point of view. Even though a rudimentary brain and spinal cord are present toward the end of the first trimester, they are as yet undifferentiated for neural functioning; it is not until much later that the fetus is as sentient as one of the higher mammals, they think. Shannon and Wolter make several observations that deserve emphasis. First, the phrase "moment of conception" used in church documents

is problematic, unless "moment" is taken in an extremely metaphoric way. Second, because of the possibility of twinning, the fetus in the earliest stages of pregnancy is neither an ontological individual nor necessarily the immediate predecessor of one. Finally, since ontological individuality is a necessary, if not sufficient, condition for human personhood, the fetus in the earliest stages of pregnancy is not a human person.[12]

The view that human ensoulment is coincident with fertilization (or at least occurs as early as possible after fertilization) seems to have been first defended in modern Catholicism by Thomas Fienus of the faculty of medicine at the Catholic university at Louvain, not coincidentally, we think, in the seventeenth century. De Dorlodot emphasizes that belief in a homunculus fostered belief in early ensoulment and made it possible for the latter to catch on.[13] However, we can see here where our view differs significantly from that of Shannon and Wolter. They suggest that even though belief in a homunculus has been discredited, we do not necessarily have to change significantly our condemnation of abortion at any stage of pregnancy. They seem to defend the view that theoretical openness regarding when hominization or human ensoulment occurs should not lead to "any rash or precipitous practical action." It is unclear to us, however, why killing a nonsentient being is rash or precipitous. We do it all the time with equanimity when we mow the grass or cut out cancerous tumors. (We will return to this issue again in the afterword, where we will consider the argument from marginal cases, an argument that will help us to make comparisons concerning the moral status of fetuses—early and late—relative to those of plants, nonhuman animals, and mentally defective human beings.) Or again, on the theory of immediate hominization we should be morally bothered by the death of fertilized eggs that do not come to term, a fate met with by over two-thirds of the eggs that are fertilized. As Shannon and Wolter note, "such vast embryonic loss intuitively argues against the creation of a principle of individuality at conception." But—and this is a point not noted by Shannon and Wolter—such vast embryonic loss also

"intuitively argues" against the view that the value of the fetus in the early stages of pregnancy is great.[14]

The central nervous *system* starts to develop in the second trimester, but it is not integrated and working until the third trimester when neural pathways are connected through the thalamus to the neocortex. This allows stimuli to be received and activities to be initiated. It is only at this point that we can begin to apply the standard definition of personhood used in Catholic moral theory by Shannon and Wolter and others; namely, an individual being of a rational nature: "One can speak of a rational nature in a philosophically significant sense only when the biological structures necessary to perform rational actions are present, as opposed to only reflex activities. . . . The presence of such a structure does not argue that the fetus is positing rational actions, only that the biological presupposition for such action is present."[15] Shannon and Wolter stress that "immaterial" individuality comes into existence late in the fetal development of the "physical" individual, for if there is no central nervous system functioning, it is not clear that the rational part of the definition of a person can be fulfilled. In short, it takes until the third week even to have "physical" individuality in place, and it takes until the end of the second trimester or the beginning of the third trimester to have a human person in place, *if* sentiency and capacity for rationality are necessary conditions for being a human person.[16]

Shannon and Wolter are commendably bold and clear in their treatment of current biological data and in their treatment of theological mistakes made in light of seventeenth-century biological data. But they are not so bold in their attitude toward current efforts to continue to defend ontological opposition to abortion in the early stages of pregnancy, an attitude they present in terms of a "prayerful process of discernment."[17] That is, there is a conflict in their thought between: (1) their belief that abortion in the early stages of pregnancy is a "premoral evil," since "one needs always to respect life" (even the life of a plant cell? even the life of a cancer cell?); and (2) their belief that from the

"moment" of conception the life of every human being "is to be respected in an absolute way."[18] Note the contrast between "premoral" in belief (1) and "absolute" in belief (2).

Shannon and Wolter are to be commended for trying to gain greater coherence between moral theology and modern embryology. And they are also to be commended for defending de Dorlodot's remarkable evaluation written over sixty years ago: "We are not exaggerating in the least when we regard the fact that this theory [immediate hominization] should still find defenders long after the experimental bases on which it was thought to be founded have been shown definitely to be false, as one of the most shameful things in the history of thought."[19] Indeed! All Shannon and Wolter still need to do, from our perspective, is to bite the bullet that few Catholics are willing (at least in public) to bite: abortion in the early stages of pregnancy is morally permissible.

The fetus in the early stages of pregnancy is animated with what Thomists call transient forms, first of a vegetative sort, then (after the development of a central nervous system) of an animal sort. (See Dante's brilliant description in *Purgatory* of this transition.) In the seventeenth century, however, a century that Pope Leo XIII referred to as "greedy for novelties," mistakes were made that contemporary embryology has finally and decisively corrected. De Dorlodot rightly asks if we really want to perform autopsies on all women who have died, but who were nonetheless capable of conceiving before death, so as to introduce baptismal water into the peritoneal cavity; and he asks if we really want to search the menstrual flow of every woman capable of conceiving to see if the blood contains a fecunded ovum. These are odd questions precisely because immediate hominization itself is an odd position. Donceel details the "sacred butchery" that would be engaged in if we took seriously the thoughts of a 1775 defender of immediate hominization, the theologian-inquisitor F. E. Cangiamila,[20] who did not find these questions at all odd.

If Shannon and Wolter continue to be opposed to abortion in all stages of pregnancy, it seems that they must do so in one of two ways. They can oppose abortion in all stages of pregnancy on perversity grounds, as when de Dorlodot says that sexual ac-

tivity is "destined by nature for the propagation of the human race." One pays quite a price for holding this view of human destiny, as we have seen briefly already and as we will see in detail in chapter 3. Or they can oppose abortion in all stages of pregnancy by saying that a *potential* human person deserves the respect owed to an actual human person. One also pays quite a price for holding this view, as we will also see in the following chapter. Potentiality arguments lead to absurdities in their own right. If one is potentially the president of the United States one should, on the grounds of the potentiality argument, expect "Hail to the Chief" to be played when one enters the room. Or, more realistically, if one is a father of two sons, aged twenty-three and seventeen, one is potentially a grandfather; nonetheless it is premature to already call this person "Grandpa" if neither of the sons is yet a father. If potentiality for X entitles one to X, then the silly line from a Monty Python film should be taken quite seriously: every sperm is sacred.

Donceel

Perhaps some of the language used thus far in this chapter seems harsh. We do not think so. But from a rhetorical as well as from an intellectual point of view it might be helpful at this point to turn to Donceel's measured, Thomistic approach, one that is very much in agreement with those of Messenger and de Dorlodot.

It must be admitted that Thomas's views on fetal development contain a mixture of philosophical and biological argument, and the latter contains incorrect as well as correct information. Thomas's main philosophical principles (e.g., the hylomorphic principle that a human soul can only exist in a highly organized body), however, do not owe anything to defective parts of ancient or medieval biology. This hylomorphic principle still makes as much sense today as it did in the thirteenth or fourteenth centuries. In fact, without this principle we are in danger of slipping into the worst aspects of seventeenth-century, Cartesian dualism. One of the problems here is that Christianity, heavily influenced by St. Paul, often contains language that indicates an ex-

periential tension between the body and the soul, language that
can, in fact, be very useful. This language is misleading, however,
if it is taken as proof of a *metaphysical* dualism.

Donceel is instructive when he notes that not even God can
put a human soul into a rock, a plant, or a lower animal, that
divine power should not be construed to mean the ability to
make foolish impossibilities possible. The fetus in the early
stages of pregnancy has a rudimentary organization that enables
it to perform the operations of nutrition and growth, and to such
organization corresponds the vegetative soul. When sense organs
and a rudimentary nervous system emerge, a certain threshold
is reached when an ontological shift occurs as the vegetative soul
is "replaced" by a sensitive soul. This view can be articulated
plausibly in terms of phase transitions: it is possible to have a
sudden radical change after a long, gradual process of transition,
as when the temperature of water is gradually increased (or de-
creased) to the point where it turns to vapor (or ice).

Another ontological shift eventually occurs when the sensi-
tive soul is "replaced" with a human soul. In this regard Thom-
as's delayed hominization is a direct result of his dynamic
hylomorphism. On the seventeenth-century, Cartesian view,
however, the ghost can exist before the machine, just as one can
get a driver's license before one owns a car. At the Council of
Vienne, this Platonic or proto-Cartesian view was rejected in an
effort to preserve the orthodoxy of the Incarnation, of the human
nature of Christ, and of the human nature of human beings (not
a redundancy).[21] As late as the late sixteenth century, Popes
Sixtus V and Gregory XIV engaged in a debate regarding how
strict the punishment for abortion should be, but both sides of
their disagreement resided entirely within the confines of oppo-
sition to abortion on perversity grounds. And in the 1617 edition
of the Roman Ritual, printed in Antwerp, it is asserted that
"Nobody enclosed in the mother's womb should be baptized," a
formula that remained unchanged until 1895.[22]

The theory of delayed hominization was eventually given up
for both scientific and philosophical reasons. The scientific ones
have turned out to be mistaken, as we have seen, but the philo-

sophical ones are in continual need of analysis, since it is not as easy to refute a philosophical error as it is a scientific one. As we have seen, Descartes's contemporary, Pierre Gassendi, was one of the first theologians and scientists to reject delayed hominization, and we have previously referred to the famous medical doctor who was in communication with Gassendi, Thomas Fienus (or Fyens), who in 1620 published his *De formatione foetus liber, in quo ostenditur animam rationalem infundi tertia die* (A Book on the Formation of the Fetus, in Which It Is Shown That the Rational Soul Is Infused on the Third Day).[23] It must be admitted that hylomorphism is, in fact, compatible with immediate hominization, but *only if* belief in a homunculus or some other sort of preformationism is true. If there really is a full-fledged human being with a brain from the start, then there is no problem admitting that there is a human person from the start. Preformationism gave way to the theory of epigenesis, largely through the work of C. F. Wolff, where the development of the fetus is a long, complex process of maturation, organization, and differentiation. Epigenesis does not fit well with Cartesianism, where the soul is not the form of a human body, and where the human soul does not need a highly organized body in order to function.

The current anti-dualistic tendency in philosophy would seem, as Donceel urges, to provide fertile ground for a revival of delayed hominization; but some scholars are obviously convinced by the idea that current knowledge in genetics helps to support the case for immediate hominization. Consider, however, the following two examples: (1) when a human heart is taken out of a deceased donor in order to be transplanted into another person, it has a full human genetic complement, but it is not considered to be a human person. But it should be so considered if possession of human chromosomes is a sufficient condition for being a human person, as the contemporary defender of immediate hominization is likely to allege. This human heart is, in fact, alive, but it does not possess the organs that are the necessary, if not sufficient, conditions for the rational activities of human persons. (2) Or again, when brain death occurs to a human being, some of

the cells in the body—cells that contain human chromosomes—are still alive. Are these cells human persons? They are not considered so; but defenders of immediate hominization who base their defense on the evidence of contemporary genetics *should* answer this question in the affirmative. Years ago when one of us worked as an orderly in an emergency room, it was routine to take what all of the doctors and nurses thought was a dead body to the hospital morgue before all of the cells in the body were dead. Should we have waited a few days or longer until all of the genetic material itself was fully decayed? We think not. These examples point to strong reasons for thinking that having a full genetic complement for *homo sapiens* is not a sufficient condition for being a human person.

Minimally, we would claim that there are two plausible ways to use the evidence from contemporary science to bolster one's position regarding the ontological status of the fetus: (a) a use of genetic evidence to bolster the case for immediate (or near immediate) hominization; or (b) a use of evidence regarding the gradual development of a central nervous system to bolster the case for delayed hominization. The former cannot be legitimately used in a hegemonic way to crowd out the latter. If one adopts the latter view, however, it is possible to marvel at—indeed it is necessary that we marvel at!—the genetic complexity of the *potential* human person found in the early stages of pregnancy. Maximally, it can also be claimed that immediate hominization is an inferior position because it is indicative of a (seventeenth-century, Cartesian) dualism, rather than of an incarnational, dynamic hylomorphic view of human nature, which is incompatible with Cartesian dualism.

An example of the hegemony mentioned in the previous paragraph can be found in James Reichmann, S.J.'s comparatively recent Thomistic textbook, *Philosophy of the Human Person.*[24] Reichmann follows Thomas in denying that the generative act itself, which is "merely physical," could account for the actualization of a new form that is intellective in nature, and is hence, *in a way,* transphysical. That is, Reichmann is like Thomas in opposing traducianism (literally, "to-hand-over-ism"), the belief

that parents themselves hand over immaterial life to their children. Like Thomas, Reichmann defends divine creationism rather than traducianism. We agree with Reichmann here. But the key question is: when does such creation occur? Reichmann seems to opt for the view that it occurs "from the first moment," but he also tries to hold on to the hylomorphic view that it is only through union with the body that the formal life principle becomes individualized. The union with "body" he clearly has in mind is union with a DNA code. He rightly champions "the brilliant advances" in contemporary genetics, but he dismisses altogether any effort to incorporate the equally brilliant advances in embryology in the last three centuries. The latter advances, it seems, are inconvenient in the effort to defend immediate hominization; thus, Reichmann sees fit to ignore them altogether. But when Thomistic dynamic hylomorphism and the contemporary scientific view of embryonic development are combined, delayed hominization rather than immediate hominization becomes the preferred view.

If an organism is a human person merely through possession of human genetic capital, then not only is a heart ready for transplant a human person, as is each living cell in a human body that is brain dead and whose heart has stopped beating, but also every single cell of the zygote, the morula, or the blastula, since each one of these may, if separated early enough from the others, survive with its human genes intact. Another difficulty, more often noticed, is that identical twins start out as one ovum fecundated by one spermatozoon. Biologically, it makes sense that from one cell two individuals can eventually develop, but *metaphysically* it is difficult, if not impossible, to see how one person can become two persons if a person is, by definition, an individual undivided in itself (*indivisum in se*).[25] If God infused two souls at conception, then these two souls share one body, a state of affairs that, at the very least, lacks parsimony from a hylomorphic point of view. Or better, individuals are particular joins of soul and body, therefore two persons *cannot* have the same body.

Perhaps none of these difficulties with immediate hominiza-

tion, pointed out by Donceel, are as great as the fact that, if immediate hominization is true, then over two-thirds of the human persons who have ever lived have never gotten beyond the first stage of human "personhood," since only a fraction of fecundated female ova ever reach nidification in the uterus. We noted that such vast embryonic loss is either a fact of nature that poses very few, if any, moral problems, or, if immediate hominization is correct, then the already remarkable extent of human tragedy, quite apart from the issue of abortion, is far worse than even the greatest pessimist could have imagined. The former alternative, we are arguing, should be adopted over the latter one. A protracted opposition to evolution in the womb makes no more sense than the historically protracted opposition in some Christian circles to the evolution of species. Likewise, Thomas's dynamic hylomorphic notion of a *dispositio materiae* is not only compatible with, but is actually entailed by, the contemporary notion that there can be no consciousness, much less self-consciousness, without what Teilhard de Chardin calls a very high degree of "centro-complexity," or orderly arrangement of an immense number of cells working together for the same purpose. Just as Thomas thought that there could be no rational soul before matter was disposed to receive it, so (in contemporary biological terms) there can be no consciousness—much less self-consciousness—without the sort of "centro-complexity" found in a brain, instead of merely the sort found in the genetic material found in a fecundated ovum, which starts as one cell.

It has been our purpose in these first two chapters to advance a view of abortion that rests on traditional principles in Catholicism, a view that does not rest—as does immediate hominization—on poor microscopes or magnifying glasses and/or an overly lively imagination. The view we have been defending is one that avoids not only a ghost in a machine but also, and especially, a full-fledged ghost in a microscopic machine. It must be admitted that it is often difficult to fine-tune one's moral judgments when one is dealing with processual developments, but this does not imply that such moral judgments are arbitrary. For example, it is difficult to tell whether it is a five-year-old or a

seven-year-old whom we ought to start holding morally responsible for his/her actions, but a two-year-old is too young and a twelve-year-old should already be familiar with the immorality of lying, and the like. And it is hard to tell whether we should treat eighteen-year-olds as adults or whether we should wait until twenty-one; but twelve-year-olds are too young to be treated as adults and twenty-five-year-olds should already be familiar with being treated as adults. Likewise, it is difficult to tell whether there is a morally considerable being at twenty-four weeks of pregnancy or not until twenty-eight weeks; but the single cell, or cluster of cells, present in the early stages of pregnancy are not, on Augustinian or Thomistic grounds, sophisticated enough to be seen as human persons, while a fetus at eight months is morally considerable at the very least because it is a being who is sentient in its own right, quite apart from the sentience of the pregnant woman.

We are not claiming in this chapter that delayed hominization was immediately dropped once Catholic scientists started using magnifying glasses or microscopes, so that immediate hominization took over right away. What we are claiming is that the modern tendency in Catholic circles to defend immediate hominization got its start in the seventeenth century, and this largely through the impetus given by Catholic scientists like Gassendi, Fienus, Zacchias, Riolanus, and Florentine.[26] By the end of the seventeenth century, the only sort of permissible abortion that was even discussed in Catholic circles was a therapeutic abortion to save the life of the mother. These induced but indirect abortions have, in fact, been debated in complex detail; but that debate is not our prime concern in this book. What is much more pertinent to the present study is that up until 1679 one could at least discuss the possibility of aborting an "inanimate" (i.e., early) fetus so as to save the reputation of a young woman who was pregnant outside of marriage. If abortion of an "unformed" or "inanimate" fetus was a sin of sex rather than a sin of killing (or murder), then such discussion would make sense, since the supposedly illicit sex would already have taken place and there would be no undoing *that* fact. But in 1679 an abortion of an early

fetus to save a woman's reputation was declared an error by the Holy Office. Clearly, a change in attitude toward the fetus in the early stages of pregnancy had occurred, a change that was not, in our estimation, for the better. As Charles Curran puts the point, although he does not defend delayed hominization, even in the twentieth century there are those who prefer to hold on to the notion of delayed hominization.[27]

Finally, we should note that despite Donceel's designation of the ontological view as "Cartesian," Descartes himself was not a preformationist because he still held on to the ancient belief that the embryo was formed by the fermentation in the womb of seminal particles produced by both male and female blood. The point is that it is Cartesian, seventeenth-century dualism that provides a fertile ground for preformationism in the preformationism-epigenesis debate. Clara Pinto Correia has detailed the internecine dispute within the preformationist camp itself between the ovists (e.g., Jan Swammerdam, Fr. Malebranche, Albrecht von Haller, Charles Bonnet, Fr. Lazzaro Spallanzani, etc.) and the spermists or animalculists (e.g., Leeuwenhoek, Hartsoeker, Leibniz, etc.), a dispute in which many of the parties shied away from the term "homunculus" because of its associations with the alchemy-like belief of some that quasi-scientists themselves could create little human beings or little monsters. But "the H-word" (Correia's label) is not bothersome if it is taken literally: a little human being. Once again, the details of this debate are not what concern us so much as the general point made by the Jesuit Athanasius Kircher in 1661 to the effect that in the seventeenth century the microscope and magnifying glass had become instruments of religious as well as scientific "revelation."[28]

The Importance of
Temporal Asymmetry

IN THE FIRST TWO CHAPTERS we have sketched a history of two Catholic views of fetal development and argued in favor of one view (delayed hominization) rather than the other (immediate hominization). Further, we have indicated some of the implications of delayed hominization for the abortion issue. These implications, however, can only be fully understood against the background provided by a theory of "asymmetrical temporal relations," a background that we will try to provide in this chapter. We will see that this theory of time as asymmetrical in turn has implications for the precise sort of omniscience that should be predicated of God. That is, in this chapter we will defend a "neoclassical" version of divine omniscience, a version that to some extent relies on the classical sources for belief in divine omniscience (Boethius, Augustine, Thomas, etc.) and to some extent attempts to render their views more consistent. All of the above technical terms will be defined in this chapter.

Before talking about temporal asymmetry and divine omniscience, however, we would like to look more closely at two sources that amplify the themes in the previous two chapters and that point the way toward the main theme of the present chapter. One is a book titled *The Facts of Life*, by the scientists Harold Morowitz and James Trefil, who examine in detail the

current state of scientific knowledge as it bears on the abortion debate. Thus far we have defended, within the confines of delayed hominization, the view that the fetus becomes morally considerable between twenty-four and thirty-two weeks when sentiency, and then the cerebral cortex, starts to function. (Once again, like Saints Augustine and Thomas Aquinas we see sentiency as a necessary if not sufficient condition for personhood.) At the very least, Morowitz and Trefil confirm a point that we made in the previous chapter: if some unique genetic information is a sufficient condition for deserving moral respect as a human person, then large amounts of tissue excised in operating rooms, which is normally seen as medical waste, is anything but this.[1]

Morowitz and Trefil also confirm that less than one-third of the eggs that are fertilized make their way down a Fallopian tube to the uterus and are eventually born. In effect, nature performs abortions at a much higher rate than human beings. Further, they point out the possibility, given current scientific knowledge, that in the future parthenogenesis will occur, when an egg will be fertilized and start the process of cell division without the agency of a sperm cell. If this occurs, then on the grounds of immediate hominization it seems we should even mourn a woman's menstrual flow, since a (potential or actual?) human person would have been lost.[2]

But the key issue for Morowitz and Trefil involves the cerebral cortex. Like the Catholic theologian Bernard Häring, they think that "humanness" takes on *moral* weight because of the development of an enlarged and highly developed cerebral cortex, which is something of a "second creation," according to Teilhard de Chardin. (Morowitz and Trefil, like Donceel, see the process thought of Teilhard as congenial with their intellectual projects.) The embryo at four weeks is only a fraction of an inch long, but not even the nerve cells that appear in the coming weeks constitute a functional central nervous system; or, as Thomists might put it, nerve cells alone do not constitute the sense organs that provide the *dispositio materiae* for hominization to occur. A pile of wires and switches is not the same as an

electrical circuit, and a collection of microchips is not a computer. Likewise, a functioning central nervous system with a brain, which *starts* forming around fourteen weeks, is not really operational until synapses start to appear around twenty-four weeks.[3]

It should be noted that the electrical activity detected in nerve cells at, say, nine weeks is not all that significant when we realize that there is electrical activity in *all* cells. Rather, it is only with the burst of synapse formation toward the end of the second trimester that the cerebral cortex is born. So anti-abortion films like *The Silent Scream* are, at best, misleading, and, at worst, fraudulent. Consider the following two examples. First, there are probably TV signals in the room that the reader finds herself in at present; but if there is no functional TV in the room, no images will be seen. Likewise, until the cerebral cortex is hooked up with the activity of nerve cells through synaptic connections, there is no consciousness and no pain that can be experienced by the fetus. Second, during an operation there are nerve cells sending signals but, because of the presence of some anesthesia, the cerebral cortex does not receive these signals; hence the patient claims not to have felt, say, razor sharp instruments cutting into his flesh.[4] Both examples are useful in trying to understand the beginnings of sentiency in fetal development.

It is now generally recognized that quickening is an irrelevant criterion to use when determining when a being in the womb becomes morally considerable, since even some plants can move. More importantly, stimulus-response is not sufficient to prove consciousness—think of shocking a dead animal's nerve endings so as to produce muscle contractions. But the ability to survive outside the womb—viability—is still sometimes invoked, as in the Supreme Court decision in *Roe v. Wade*. It may or may not be a coincidence that many scientists are now admitting that they are "hitting the wall" regarding the extent to which they can push back the date when premature births can be kept alive—not merely "salvaged"—so as to lead rich human lives. Specifically, the hope is waning that the date can be pushed back to a period much before the third trimester, although great progress

has been made in keeping alive (and keeping alive with the potential for rich human lives) those fetuses born from twenty-four weeks on. Whether through serendipity or through some sort of causal connection, it now seems that the onset of a functioning central nervous system with a functioning cerebral cortex and the onset of viability occur around the same time—the end of the second trimester—a time by which 99 percent of all abortions have already occurred.[5]

The second source we would like to mention in our effort to link the first two chapters of this book with the present chapter's concern for temporal asymmetry is an article by Paul Badham. Although the shift to immediate hominization started to occur in the seventeenth century (as evidenced, say, in Thomas Fienus's work mentioned earlier), and this apparently was due to (erroneous) developments in science, it was not until 1854 that a decisive theological change was made explicit. This was the date of the proclamation by Pope Pius IX of the dogma of the Immaculate Conception. If Mary was, as this dogma claimed, untainted by sin from the time of her conception, then she must have been a person from the time of her conception. This led Pius in 1869 to drop the adjective "ensouled" before the noun "fetus" when punishing with excommunication those who had abortions. Hence, according to Badham, early as well as late abortions became grounds for excommunication—a first in church history.

Badham also details one of the well-known possible consequences of this nineteenth-century change: abortion was immoral even for ectopic pregnancies, when the mother's life is in danger as a result of continuing the pregnancy. It is significant, Badham notes, that majority Catholic opinion has been, and continues to be, opposed to Pius's reasoning on this point. For example, the principle of double effect provides a piece of casuistry in the effort to avoid the counterintuitive practice of allowing pregnant women to die as a result of ectopic pregnancies: the intended, direct effect of a humanly induced abortion in an ectopic pregnancy is the elimination of the threat to the pregnant woman, whereas the expulsion of the fetus is a foreseen, but not intended, effect of this sort of abortion. Badham sums up the

matter well regarding the doctrine that an early fetus and a pregnant woman are on a moral par: "I suggest that the fact that in practice Catholic doctors find it morally impossible to treat the lives of a foetus and mother as having equal significance, is itself a ground for questioning the validity of a doctrine which asserts it."[6] But even if the principle of double effect can be used successfully to deal with the problem of ectopic pregnancies and to shore up the theory of immediate hominization (which we doubt), it is unlikely that it can offer much help to the defender of immediate hominization in the effort to argue against the vast majority of abortions, which occur early in pregnancy.

The early Christians such as Augustine were worried that unbaptized aborted fetuses would end up in hell, and their medieval successors worried that such fetuses would live in the half-world of limbo. Even if these concerns strike most contemporary Catholics as largely beside the point, and even if some of Thomas's beliefs are obviously remnants of a worldview that is very much out of date—as when he thinks that fetal hominization occurs sooner in males than in females, or as when he thinks that the heart rather than the brain is the central organ of sensation—there still is much to be said for Augustine's and Thomas's defense of delayed hominization on the basis of contemporary science *and* contemporary theology. This is the reason that we think we should take Morowitz-Trefil and Badham seriously.

Purely Internal Relations

We have seen that philosophical opponents to abortion, both inside and outside of Catholicism, usually base their opposition on the claim that the fetus is a human person, so that it is murder, or something close to murder, to abort it. This claim, in turn, is based on a logic of symmetrical relations whereby human identity can be attributed to a being whether it is viewed in its transition from past to present *or* in its transition from present to future. In the remainder of this chapter, we will freely use the thought of Charles Hartshorne to take issue with opponents of abortion. Specifically, we will criticize the use they make of sym-

metrical temporal relations, a use that has (surprisingly, given the attention abortion has received from philosophers) largely been ignored by scholars.

We will present our view as a mean between two undesirable extremes: (a) The seventeenth-century view defended by Gottfried Leibniz is that all events in a person's life are *internally* related to all the others, such that implicit in a fetus are all the experiences of the adult, and this due to God's eternal "foreknowledge" of everything that is to happen. This view is a symmetrical one in that a person in the present is internally related not only to past phases of itself but to future phases of itself as well. (b) An equally disastrous view is one that, although it would permit abortion, provides insufficient grounds for showing respect for even an adult human being. This is the view of David Hume and Bertrand Russell that, strictly speaking, there is no personal identity, because each event in "a person's life" is *externally* related to the others. Despite the obvious differences between these two views, they are both symmetrical, as we will show. That is, a theory of pure external relations leads to a symmetrical view because the present moment of a human life is not only externally related to "its" future phases but also to the past phases of "its" life.

The view we will defend is an asymmetrical one: a human person in the present is internally related to her past phases, but is only externally related to her future phases, if such there be.

Let us consider the defects in the Leibnizian view first, a view that relies on a certain stance regarding divine omniscience often held by Catholics and presupposed, it seems to us, by most contemporary opponents to abortion. "If I was already 'myself' in childhood, still *that* self did not have and never can have my adult knowledge."[7] That is, in its memories the adult has its childhood, but no child can have its adulthood, according to the view of time as asymmetrical. There is a partial but not a complete identity between a child and an adult. Leibniz's unqualified identity theory (which, again, rests on a view of divine omniscience of which many Catholics are fond) fails to take into consideration these implications of temporal becoming for human

identity. Do young persons really identify themselves with the elderly persons they *may* eventually become? Hardly.

If one supposes that a person is simply one reality from before birth until death (or after), then one is in effect denying that with each change in life we have a partly new concrete reality; one would be implying that there is a strictly identical reality with merely new qualities. But, contra the Leibnizian view, to say that Mary is "the same person" day after day and year after year is primarily to say that she does not become a geranium or anything other than a human person, and that she does not become Jane. This leaves open the possibility that Mary on Friday and Mary on Monday are somewhat different realities, both quantitatively (one is older than the other) and qualitatively (Mary on Monday has actually had experiences over the weekend that Mary on Friday could only imagine).[8] The "identity" between the two Marys is real, but it is an abstract reality rather than any concretely lived experience. That is, human identity is a non-strict identity, as opposed to Leibniz's (and, it seems, the opponent of abortion's) theory of strict identity.

A non-strict identity is composed of two or more successive concrete actualities with partly identical and partly differing qualities. It makes sense to claim that a person in a later state includes that person in an earlier state, *but not vice versa*. For example, only I remember my past in the inward way in which I remember it, though even I remember it vaguely and partially.[9] The point is that I-now cannot be adequately described without mentioning my past, but I-then could have been (could only have been!) adequately described without mentioning I-now because I-then never experienced I-now.

The fact that one's past self is in some significant sense "another" self should not be underestimated, especially when the issue of abortion is considered.[10] To claim that a "substance" is an identical entity through time, containing successive accidental properties, is really a misleading way of describing an individual enduring through change. Successive states are not so much "in" the identical entity as it is in them.[11] At a given moment a human being is definite, and she is definite in her

history up to that point, but until she dies her future is at least partly indefinite, even with respect to the immediate future, and perhaps largely indefinite with respect to the distant future. If it makes sense to say—as it obviously does—that this human being could have had a somewhat different career up to the present, then she is a partly indefinite entity. That is, a human being is not, in spite of the Leibnizian view that is presupposed by contemporary opponents to abortion, the same as her career. The latter is an abstraction in comparison with the concreteness of lived experience.[12]

There is a certain bias in the history of philosophy from which it has painfully tried to free itself, namely, the favoring of one pole of conceptual contrasts at the expense of the other pole. Being has traditionally been preferred to becoming, identity at the expense of diversity, et cetera. The prejudice in favor of being as opposed to becoming is related to the theory of strict identity. If all events in a person's life are real together (say in the mind of God), then the totality of events simply is, with being and not becoming as the inclusive conception.[13]

The Leibnizian view of human identity we are here criticizing clearly exhibits this bias. The hope of defenders of this view has been that, by attacking the idea of a partially changing identity, one could make secure the true reality or true being of an individual. An unintended consequence of this view is that it leads to determinism, and we assume that determinism is at odds with the traditional Catholic defense of human free will. If the future is just as internally related to the present as is the past (i.e., if the present is just as much affected by the future as by the past), then what are normally called future contingencies merely refer to our ignorance of what is already in the cards.[14] It is no accident that the strict identity view is often based on the theory that God knows with absolute assurance and in minute detail the outcome of future contingencies, a theory that traditionally, and understandably, has run up against the objection that such *absolutely certain* knowledge would eliminate the possibility of free will and future contingencies. On the symmetrical theory

of strict identity, all change consists in attaching predicates to a strictly identical subject (or substance) that endures throughout the succession of predicates. This seems to imply that substances are eternal (in the mind of God) in that, being changeless, they are incapable of creation or destruction.[15]

The ordinary use of personal nouns and pronouns is perfectly compatible with the asymmetrical, process, non-strict view of identity we are defending. I am me and not any other person.[16] The series of experiences of which I have intimate memory contains no members of your series. It is not true that only defenders of strict identity can explain the persistence of character traits, whereas event pluralists who defend non-strict identity can only give grudging recognition to these traits. Identity is not so much in dispute as its analysis; that is, whether its structure is symmetrical or asymmetrical. Obviously, I am in some sense numerically the same person I used to be; but it is equally obvious that in some sense I am a different person, even numerically different in that I have *more* past experiences as constituents of who I am. It is my present, however, which contrasts itself with my past, not the other way around. The old reality enjoyed or suffered no contrast with what came later; at best it only vaguely anticipated what came later. "Life is cumulative, and hence asymmetrical in its relatedness."[17] The Leibnizian view presupposed by contemporary opponents to abortion stumbles in viewing self-identity as merely numerical oneness, with at most a plurality of qualities. Or, to make the point linguistically, a single noun with many adjectives.[18]

Genetic identity is a special strand of the causal order of the world, and rests on the same principle of inheritance from the past as does causality in general. Even the memories of our earliest moments form part of our individual natures. But it is not until there is a developed fetus (to be discussed again momentarily) that the particular events that prolong existence are additions to a *personal* sequence.[19] By way of contrast, Leibnizian strict identity implies—although this implication is seldom noticed or admitted—that nothing a person does or that happens

to that person could have been otherwise.[20] Once again, future "contingencies" are, on the symmetrical view of purely internal temporal relations, merely signs of our ignorance of what God already knows will happen to us. On this view, we are, at the very least, logically determined, if not physically coerced, to do what God already knows (with absolute assurance and in minute detail) we will do. We are alleging that in order to avoid the untoward implications of the Leibnizian view, one needs to posit the concrete determinate actuality in the present (which in some way preserves its past) as that which "has" properties.[21]

Although we will show in detail later in this chapter the connection between asymmetrical temporal relations and the issue of abortion, we would like to briefly introduce this connection here through a consideration of Aristotle. He, as has been noted above, greatly affected (whether directly or indirectly) Augustine and Thomas. Tracing the conception of the human person as substance back to Aristotle is a commonplace in philosophy, but it would be a mistake to think that Aristotle saw the future careers of individuals as definite. Aristotle believed in at least a partly indeterminate future that could not be known in minute detail. Well-informed Aristotelians like I. M. Bochenski, O.P., have admitted that human reality consists in a (personally ordered) series of events.[22] The technical jargon of process philosophy can be seen as an attempt to dot each "i" and cross each "t" of Aristotelian concepts like *dynamis, energeia,* and future contingency. An individual career (i.e., an event sequence), once begun, has the potentiality for its later prolongations. But it is an open question in Aristotle scholarship whether it is better to say that the actualization of a potency is contained in the potency or that the potency is contained in the actualization. If the present is more than the past, there is a new whole of determinations in the present and the latter alternative is more accurate. Events are capable of being superseded by what is more than they are, for example, an infant self does *not* contain the adult phases of itself, nor does the early fetal "self" contain the infant phases of "itself," as we will see.

Purely External Relations

The reasonableness of the theory of non-strict, temporally asymmetrical identity can be seen when it is contrasted with a second extreme that is equally symmetrical. Hume, Russell, and some Buddhists have overstated the non-strictness of human identity by claiming that *all* temporal relations are external; hence, strict identity theorists may rightly fear this view.[23] But before showing what is defective in the theory of purely external relations, we would like to indicate its grain of truth. The theory of purely internal relations starts with a correct intuition regarding the need to explain the persistence of character traits, but it grossly overemphasizes the personal continuity needed to preserve these traits. Likewise, the theory of purely external relations (in Buddhism, especially) starts with the legitimate insight that the qualification of personal identity allows for at least partial identity with others. The "no soul, no substance" doctrine of certain Buddhists enables us to understand St. Paul's claim that we are members one of another. That is, self-love and love of others are on much the same footing and neither makes much sense without the other,[24] especially when it is realized that my previous self is to some degree an other self from the one I am now.

From this insight, however, defenders of external relations such as Russell show no more hesitation than Leibnizians in accepting symmetrical relations. If events in nature are mutually independent, then nature is analogous to a chaos of mutually independent propositions.[25] The defender of asymmetry (who views a present person as internally related to his past but as externally related to "his" future) finds it comical to see Russell attacking rationalists like F. H. Bradley because they have little or no use for anything but internal relations. And it is equally comical to see partisans of purely internal relations, such as Leibnizians (who are opposed to abortion) or Bradley or Brand Blanshard, trying to refute Hume, Russell, or William James.[26]

One defect in the theory of purely external relations is that we do in fact usually talk as though events depend on what happens

before but not on what happens afterwards; we do talk as though asymmetry is the case. This in itself does not refute a Hume or a Russell, but it should lead defenders of purely external relations to wonder whether believing in events as dependent both ways (i.e., present dependent on past and present dependent on future) is any worse than believing in events as independent both ways.[27] There is also the familiar difficulty of preserving moral responsibility for one's past actions if one is not internally related in some way to those actions. The "drops of experience" view defended by those who see time in a symmetrical way, dominated by external relations in both directions, can lead to some unacceptable moral results, to say the least—as in a murderer looking back on the killing he did and declaring that it was a different person who committed the crime. Or consider the following clever and, we think, devastating example from Hartshorne: "One may parody the prejudice of symmetry as follows: Suppose a carpenter were to insist that if hinges on one side of a door are good, hinges on both sides would be better. So he hangs a door by hinging it on both sides, and it then appears that the hinges cannot function, so that the door is not a door but a wall. 'We'll fix that,' says another carpenter, and removes all the hinges. So now the door is again not a door, but a board lying on the floor. This is how I see the famous controversy about internal and external relations."[28]

The moral here is that one is "hinged" to one's past, but not to one's future. That is, the first carpenter is like the ontological opponent to abortion who believes in internal relations both ways. More complications set in when we see that a symmetrical theory of purely internal temporal relations leads, as Bradley realized, to monism, whereas a symmetrical theory of purely external temporal relations leads, as Russell realized, to a radical pluralism. Russell's mistake was in assuming that one *had to be* either an absolute monist or an absolute pluralist and that one could not benefit from the strengths of both internal *and* external relations.[29] Defense of purely internal temporal relations leads to the erroneous conclusion that we can *only* expect what laws governing the internal relations will allow; and the view

that emphasizes purely external temporal relations *should* lead to the conclusion that at each moment anything conceivable could happen next.[30] Commenting on Russell, James, and others, Hartshorne makes the following astute observation: "The combination of extreme causal determinism and extreme pluralism (lack of any internal relations connecting the constituents of reality) repeated the most bizarre feature of Hume's philosophy. The combination violently connects and violently disconnects the constituents of reality."[31]

Implications for Abortion

In the above sections of this chapter the implications for abortion of a theory of human identity based on a theory of asymmetrical temporal relations were stated at least implicitly. The purpose of this section is to make these implications explicit, an effort that is facilitated by noting the defects in the two theories of symmetrical temporal relations. We will make these implications explicit by noting the texts where Hartshorne himself explicitly refers to abortion or to fetal development.

Most who use the contemporary slogan "respect for life" seem unaware of the vast gulf in quality between experiences open to a fetus compared to experiences possible for a walking, talking child, not to mention the mother of the fetus. The question should be, respect for life on what level? A single human egg cell is alive, but it has no experiences in the usual sense of the term; an adult, or a child, or even an animal with a central nervous system does have experiences.[32] Augustine did well to compare a fetus in the early stages of pregnancy (before the development of a central nervous system, which, as we now know, makes sentiency possible) to a plant. No egg cell, fertilized or not, can simply turn itself into a truly human person if sentience is a necessary condition for personhood. Only help from others can do that. Just as we need a mean between extremes regarding temporal relations—avoiding both a confused monism, where all things are rigidly interdependent, and the anti-metaphysical pluralism of the early Ludwig Wittgenstein and of Russell, where

all things are radically independent—so we also need a mean between injudicious extremes regarding respect for life.[33]

If to be a person in the fullest sense is to be conscious, rational, and have a moral sense, then a fetus in the early stages of pregnancy is, *at best,* a probability of a person. Hence, those who equate abortion with murder are misguided; we say this on the basis of what we think are convincing reasons from Augustine and Thomas. Not even the probability of there being something is actually something, especially when the probability can only be realized with considerable effort and sacrifice on the part of others. As we have noted in a previous chapter, if one is potentially the president of the United States, one does not insist that "Hail to the Chief" be played when one enters the room. Or again, if someone will probably be a grandfather some day, it is nonetheless premature to call him "Grandpa" before one of his children becomes a parent. Here it will perhaps be objected that the potentiality of the fetus early in pregnancy is not a passive potency but an active potency "which is a guarantee of the future," to use the language of Francis Wade, S.J. But this view leads to all of the traditional flaws associated with a deterministic theory of purely internal relations, for there simply is no such guarantee.[34]

It must be admitted, of course, that the chances that any one of us will become president are obviously very slim, so that this example is not the best one to illustrate the natural, organic development of the fetus. But the chances that a forty-four-year-old with two sons will become a grandfather are at least as good as those that a fertilized egg will become a human person. This example is therefore a better one to illustrate the natural, organic development of the fetus. Since less than one-third of fertilized ova are eventually born, quite apart from humanly induced abortion, the odds here are probably less than those of the potential grandfather. The potentiality of a fertilized egg is more internal to it than is the potentiality to become a grandfather; but in each case there are external factors that must be realized in order to obtain a late-term fetus or a grandchild, respectively.

It changes the whole quality of life to learn that there are

murderers about, but it is not clear that we need be bothered by the fact that there are abortionists about. "The human value of the embryo is essentially potential and future, not actual and present."[35] The functioning that it does *actually* exhibit is nothing especially exalted when compared to other beings, even a great many nonhuman beings. Of course, even the potentiality of an early fetus has some value. But *this* value (even plants have some—largely instrumental—value) is nothing absolute, as we will see in the afterword, and should be weighed against the values of those beings—especially the mother—who are *actually* functioning at a much higher level. Moreover, although some "pro-life" advocates argue that the aborted fetus could have turned out to be a genius, this is not the same as actually being a genius. The aborted fetus could also have turned out to be a murderer. It is unclear, to say the least, how one can make the status of a pre-sentient cluster of cells more or less exalted by considering what it *might* eventually become.[36] The low percentage of fertilized ova that are born, quite apart from abortion, indicates that there is nothing probable, much less assured, about an early fetus going through a natural, organic development so as to achieve human *telos* (or fulfillment).

Randolph Feezell comes close, but not close enough, to the view of abortion we are defending. Although our criticism is primarily directed against strict identity theory based on symmetrical temporal relations and on a strong view of divine omniscience with respect to the future (i.e., with what Feezell calls the conservative view of abortion), it also has implications for Feezell's moderate view, which criticizes the casual attitude that some (he calls them liberals) may have toward the fetus, which is a "soon to be actual" person.[37] At times, Feezell is careful to refer to the (early) fetus as a future (i.e., possible) person, but he then seems to attribute rights on that basis. This attempt only succeeds, however, when Feezell almost imperceptibly slips into the strict identity view (i.e., the conservative view, the view based on a symmetrical theory of purely internal relations). Consider his claim that "at conception a unique chromosomal combination occurs, and that is the basis for speaking of some

identifiable *potentiality* which *will be born* and *will develop* into that person whose history we must *now* morally consider" (our emphasis).[38] Feezell also says that "the death of the fetus is a severe misfortune for *the person* whose possibilities have been negated" (our emphasis).[39]

Our criticisms are as follows: if a fetus is a potential (i.e., future) person, as Feezell usually admits, why should we grant it human rights *now*? (In our view, being a human person is a necessary condition for possessing human rights.) To say that it should have human rights now because it *definitely* will be born and *definitely* will develop into an infant is to slip subtly into the strict identity theory based on symmetrical temporal relations. That is, if Feezell had said, consistently, that a fetus (in the wide sense of the term that includes whatever is alive in a woman in the early stages of her pregnancy) *may* eventually be born and that it will *perhaps* develop into a person, a more accurate description of the fetus's mode of existence would be given, such that there would be less of a tendency to treat the early fetus as a bearer of human rights. Feezell is correct that fully actual persons are the subjects of misfortune,[40] as are sentient potential persons, but we are not convinced that pre-sentient potential persons, because they exist in space and have a history, are also (albeit, according to Feezell, in a "weaker sense") subjects of misfortune. The question is: what *sort* of actuality does the historical being in question have? Rocks also occupy space and have a historical route of occasions making up their careers, but we think that rocks lack sentiency and that sentiency is a prerequisite for suffering misfortune—indeed, for suffering at all.

Feezell is also correct in pointing out the asymmetry we would adopt regarding prenatal nonexistence and posthumous nonexistence.[41] We are not unhappy about the former, but it makes perfect sense to be bothered about the latter. We do not think that death as such is an evil, but it does make sense to grieve over the premature or ugly or violent death of a sentient being, and this grief is intense when the sentient being is also a human person. But these types of death bother us because an actual person who

was capable of being harmed—who actually had hopes for the future, hopes that existed in the present—was cut down.

In the end, however, Feezell's moderate view (which leans toward what he calls the conservative view) is not too much different in its practical effect from our or Hartshorne's moderate view (which leans toward what Feezell calls the liberal view). We think that abortion is permissible only in the early stages of pregnancy. As the fetus starts to develop a central nervous system, it has a moral status analogous to that of an animal, a status that we think deserves considerable attention.[42] In Thomistic terms, once the fetus has a functioning central nervous system, it moves from a vegetative state to a sentient one; and once the cerebral cortex starts to function shortly after the functioning of a central nervous system, it moves from a sentient state to a properly human one. That is, we think, as does Feezell, that a fetus in the later stages of pregnancy should be treated with respect. As before, all of these judgments are consistent with traditional principles defended by Augustine and Thomas. These principles include the idea that sentience (which provides the *dispositio materiae* for rationality) is a necessary but not sufficient condition for human personhood.

Joel Feinberg and Barbara Baum Levenbook also defend a view that is similar in its practical effect to the one that we propose. Feinberg rejects what he calls a "modified or gradualist" potentiality criterion for moral *personhood*. This criterion says that "potential possession of [the capacities of 'commonsense' personhood] confers not a right, but only a claim to life, but that claim keeps growing stronger, requiring ever stronger reasons to override it, until the point when [the capacities are] actually possessed, by which time it has become a full right to life." He opposes this criterion because *actual* rights cannot be derived from any *potential* qualifications for them. But, he writes, "[I]t seems that a gradualist approach . . . is a more plausible solution to the general problem of the moral justifiability of abortion than it is to the narrow problem of the [proper] criterion of moral personhood." Why? Here Feinberg appeals to the "widely shared

feeling [which we share] that the moral seriousness of abortion increases with the age of the fetus." His suggestion is that the moral considerability of a fetus increases *along with* its development: "for the first few weeks of its life, the fetus . . . has hardly any claim to life at all . . . but as the fetus matures, its claims grow stronger, requiring ever stronger claims to override them," until only the strongest of claims by others (the mother's life, e.g.) can be overriding.[43]

Feinberg's gradualist approach is in line with our own. While we think that sentience marks an important threshold—we would call it the threshold of moral patiency—we do not agree with those, such as L. W. Sumner, who seem to regard sentiency as the *only* definite line for significance. On Sumner's view, abortion *before* the onset of sentience is the moral equivalent of contraception—which he does not think that any reasonable person should find problematic—while abortion *after* the onset of sentience is equivalent to infanticide.

The early fetus is obviously alive, as is grass, and it is obviously human *in the sense that* it has human parents and a human genetic structure. But if what we have said regarding asymmetrical relations and human identity is correct, the primary moral question becomes: when does an individual human fetal life become as valuable as the life of an animal? And the secondary question becomes: when does an individual human life become more valuable than that of a "mere" animal? Our response to the first question is: when a central nervous system and concomitant sentiency starts to develop. A response to the second question is much more difficult to make.[44] Previously, we have suggested that what is distinctively human starts to appear around the end of the second trimester when the cerebral cortex starts to function. At this time a fetus can legitimately be seen as a moral patient (i.e., it can legitimately be seen as human in the moral sense of the term) because of the real capacity it has for rationality, a real capacity to be something more than a sentient animal. It should be noted that this real capacity is not yet actualized, so there is indeed a period where it is difficult—in the absence of knowledge of the precise time when God infuses a soul

into a fetus sufficiently developed to receive it—to morally distinguish between sentient yet nonrational animals and sentient yet nonrational human beings. Not even an infant reasons in any sense equally with, or beyond the capacity of, dogs, apes, or porpoises,[45] although even the infant is enormously superior to a fertilized egg in many morally relevant respects: levels of consciousness, sentiency, fear, and so on.[46] From the fact of infant inferiority, however, we should not be driven in a Michael Tooley–like direction toward the moral permissibility of infanticide,[47] but rather toward a Franciscan protection of the lives of animals. They are *actually* sentient and it is a fundamental moral axiom that no being that can experience pain or suffering ought to be forced to experience pain or suffering gratuitously.

The point we are trying to make here is not only that a fetus in the early stages of pregnancy is not a moral agent but also that it must go through a certain period of development to reach the threshold of moral patiency. That threshold is sentiency. Only after sentience is acquired can we even begin to compare fetuses to other beings who are not moral agents but who are moral patients and the subjects of misfortune: the comatose, the severely retarded, nonhuman animals, and so on. It is difficult, if not impossible, to imagine how we could consistently generalize the claim that non-sentient beings have rights. For example, if vegetative beings have rights, then human beings would likely starve, since they would have little, if anything, to eat. The equal value of the possible and the actual "is not an axiom that anybody lives by or could live by."[48] Even on strictly anthropocentric (human-centered) grounds, it is not an axiom with any pragmatic value, as we will argue in the afterword.

Equally problematic is the adjective "innocent" used of fetuses, a term that has at least two senses. It may very well be the case that we ought not to kill the innocent not because they are guiltless but because they are not harming us at this time. (That is, there are such things as "innocent threats.") If a fetus poses no harm to the pregnant woman, it is innocent in this sense of the term. However, the usual sense of the term contrasts with "guilty" or "culpable." Only if those who saw abortion in the

early stages of pregnancy as morally permissible had ever claimed that fetuses were wicked and ought to be punished could the innocence of the fetus be a moral consideration. In this second sense of the term, the "innocence" of the fetus is like that of the animals: an incapacity to distinguish right from wrong but a capacity to experience pain. Here fetal innocence deserves consideration *once it has achieved* this capacity but not before.[49]

A classic case of human beings becoming entangled in their own language is exhibited when opponents of abortion ask: "How would you have liked it if your mother had aborted you?" An adequate response presupposes a responsible use of pronouns. I would neither have liked nor disliked the abortion, because before the advent of sentiency there would have been no "I" at all; and for some time after the development of sentiency, there would have been fetal "innocence" (in the sense of guiltless) but only a tenuous selfhood at work.[50] Once again, an understanding of the theory of asymmetrical temporal relations is what enables us to see that:

> The "pro-life" literature is mostly a string of verbally implied identifications of fertilized egg cell with fetus, of fetus with infant, infant with child, child with youth, youth with adult. I repeat, any cause is suspect which ignores or denies distinctions so great. . . . I have respect for the fetus as . . . a wondrous creation . . . it is capable of eventually, with much help from relatively adult persons, becoming first an infant (and then a child). . . . We are all human *individuals* long before we are *persons* in the value sense of actually thinking and reasoning in the human fashion. Even in dreamless sleep as adults, we are not actually functioning as persons; but this does not abolish the obviously crucial difference between a fetus whose potentiality for rational personhood requires at least many months of help by actual persons to be actualized even slightly, and a sleeping adult who has already functioned as a person for many years and who has made many plans for what it will do in its waking moments, perhaps for years to come.[51]

During the first weeks of pregnancy, an embryo is but a colony of cells—"itself," as a whole, not much of an individual at all. Those who are offended by the claim that cows and chimps[52]

deserve more respect than the fetus in the early stages of pregnancy usually resort to a type of question-begging that can be called "speciesism": the human fetus in the early stages of pregnancy deserves moral respect just because it *is* human. To avoid begging the question as to *why* the embryo deserves moral respect, the opponent to abortion might resort to something like what we have called the theory of strict identity based on a symmetrical theory of temporal relations. But if, as we have tried to show, this theory has more defects than its asymmetrical alternative, then opposition to abortion in the early stages of pregnancy is, at the very least, questionable.

No doubt, defenders of strict identity will conflate the asymmetrical view with the theory of purely external relations by claiming that both theories make human identity too fragile. Our response to this claim is, in a strange way, a sympathetic one. In the theory of purely external relations there is no real human identity through time, whereas in the asymmetrical view there is only a fragile human identity. But it is not "too" fragile. The asymmetrical view leaves human beings, in contrast to God, "as fragile as they are and not a whit more."[53]

Divine Omniscience

We would like to make it clear in this final section of the chapter that we defend the concept of divine omniscience in the sense that God, as the Unsurpassable Being-in-Becoming, would, as a consequence, have to be the Unsurpassable Knower. But this does not mean that God could know logical impossibilities. Rather, God knows all that is logically possible: God knows all past actualities *as* already actualized; all present events in their presentness (subject, of course, to the laws of physics) as they come to pass; and future possibilities (or probabilities) *as* possibilities (or probabilities). That is, God knows *all* future possibilities better than any human knower, but God does not know *any* future occurrence—whether it be a physical happening or a human action—in minute detail and with absolute certainty, because the future is always at least partially indeterminate.

To claim to know a future possibility as already actualized is not an example of perfect, divine knowledge but rather an example of ignorance or fraudulence. Obviously, it is impossible to know the concrete details of the world as God knows them, but in general outline it seems fair to say that the greatest sort of knowledge of future possibilities (or probabilities) is to know these possibilities or probabilities *precisely in their indeterminacy.* It is no great accomplishment to "know" the future as one knows the past, since one would then not really be knowing the future *in its futurity.* There are certain well-known texts in the later Augustine and in John Calvin where it is argued that belief in strong divine omniscience leads (or should lead) to determinism. But surely this is not the only Christian or Catholic way to view the matter, especially when it is considered that human freedom—which, we take it, is a nonnegotiable item in Catholicism—presupposes that there be a certain degree of indeterminacy with respect to the future.

We argue that God is omniscient; but no being, not even God, can know with absolute assurance and in minute detail what will *in fact* happen to an embryo in the early stages of pregnancy. God must be as great as possible at any particular time, or else God would not be the Greatest Being-in-Becoming. But new moments bring with them new possibilities for greatness, which God must realize in the best way possible if God is the Greatest Being-in-Becoming, or better, the Unsurpassable. This means that God is greater than any being who is not God, but that God can always—must always!—surpass previous instances of divine greatness. It does not mean that God's earlier existence was inferior, because it was at that particular time the greatest conceivable existence, the greatest existence logically possible, and greater than any other being.

Consider the following example. If X loves Y, then on any love even remotely analogous to human love, X must change when Y, who previously did not suffer, now starts to suffer. If X stands for God, the greatest lover, and Y for creatures, then one can see why it is crucial to think of God in process terms. Not to do so would create the nastiest version of the theodicy problem (the

problem of evil) in which God knows with absolute assurance and in minute detail before the fact that human and other sentient beings—including fetuses in the later stages of pregnancy—will suffer, but allows such suffering to occur nonetheless. It is *this* "God," we think, that is not worthy of our worship, in contrast to what Alfred North Whitehead refers to at the end of *Process and Reality* as the Fellow Sufferer Who Understands—the God sublimely symbolized on the crucifix.

We would like to conclude by noting that within Catholicism there have been different interpretations of what it means to say that God is omniscient. We are only objecting to one of these interpretations, the one that involves a theory of pure internal relations (both ways) such that determinism is the likely result. Although this theory arises out of certain assumptions found in the Stoics and in the later St. Augustine, the continued emphasis in Catholicism, in particular, and in Christianity and theism, in general, on human freedom and future contingency should indicate that we need not assume that this deterministic version of divine omniscience is the whole story. And if other versions of divine omniscience than the one built on pure internal relations are possible, the belief that a fertilized egg is more than a potential person, but is rather a probable person or an already actual person, should be called into question.

It is interesting that Anglicans and some Protestants continued for a while to defend the Augustinian and Thomistic distinction between the unformed and the formed fetus, whereas Calvinists (and Muslims), with their very strong notion of deterministic divine omniscience, tended to believe that even the earliest stages of fetal development involved a being that was *already* fully a person. Neither Catholics nor other religious believers need be—nor should they be—Calvinists in this regard. Rather, they should agree with Pope Paul VI that a fetus is *une personne en devenir* (a person in the process of becoming), even if it is by no means clear that Paul VI was aware of the wisdom of his phrase. If he had been, he would agree with Hartshorne that it is "a very crude form of materialism to identify individuality with the gene-combination. Genes are the chemical bearers of inherited traits. This

chemical basis of inheritance presumably influences everything about the development of the individual—*influences*, but does not fully determine. To say that the entire life of the person is determined by heredity is a theory of unfreedom that my religious conviction can only regard as monstrous."[54]

The common sense of science fiction is that some beings who lack a human genetic code are nonetheless persons (e.g., Mr. Spock, E.T., Alf, etc.). Hence, if science fiction readers are right, then a human genetic code is not necessary for moral personhood. Nor is it sufficient. The fetus in the early stages of pregnancy has what can be called, in Aristotelian terms, "first potentiality," in that it has *not yet* exhibited the qualities of moral patiency. A temporarily unconscious or sleeping person, however, is like a late-term fetus in having a "second potentiality" analogous to that of a car mechanic who is not currently fixing cars: he can still legitimately be called a "car mechanic." The late-term fetus or temporarily unconscious person have *already* exhibited characteristics that require us to view them as moral patients. (The temporarily unconscious person is also a moral agent, it should be noted.) A human genetic code may underlie the development of moral patiency, but it does not fulfill it. Again, this point becomes clearer when one considers the fact that over two-thirds of fertilized ova ("zygotes") die early, for example, as a result of failure to implant on the uterine wall. If moral patiency, much less personhood, were attributed to zygotes, then this failure would constitute the gravest moral problem facing humanity, and unprecedented expenditures of resources on medical research would be justified even if the most favorable result—saving the lives of these "persons"—would increase by 800 percent or more the number of infants born with severe genetic defects.[55] But, as we have argued, immediate or near immediate[56] hominization is, at best, an implausible position.

A Defensible
Sexual Ethic

CHAPTERS 1 THROUGH 3 OF THE present book have primarily argued against Catholic opponents of abortion who defend their position on grounds provided by the ontological view. That is, they have been designed to support premise 2 of the formal argument presented in the introduction that, in outline, indicates the overall view we are defending in the book.

However, it should be remembered that throughout most of the history of Catholicism opposition to abortion has not been on ontological, but rather on perversity, grounds. According to defenders of this latter position, abortion is immoral because it indicates that the sexual relations that resulted in the pregnancy to be aborted were engaged in for the wrong reasons. Indeed, such sexual relations were, for Augustine, cruel in that the two human beings who engaged in the sexual act that resulted in an aborted pregnancy mistreated one another.

The strong version of the perversity view, sometimes defended by Augustine, is that the *only* sexual relations that are moral are those engaged in within the confines of marriage *for the purpose of* having children. A somewhat weaker version suggests that sexual relations within marriage must be engaged in with at least *the possibility of* pregnancy, as in the case of Sarah in the Hebrew Scriptures, who became pregnant at a quite old age. A still

weaker version of the perversity view holds that morally permissible sexual relations must be within the confines of marriage, and for the purpose of—or at least with the possibility of—pregnancy, but in addition such sexual relations can also be an expression of conjugal love between the married partners. As we have noted, Augustine sometimes favors the latter version of the perversity view. The danger of this weak version, however, is that to attempt to justify sexual relations because they are conducive to conjugal love runs the risk of justifying sexual relations on the grounds that they are *pleasurable* to the married partners—a situation that Augustine and other defenders of the perversity view consistently oppose.

In this chapter we are obviously not going to offer anything like a complete sexual ethic from a Catholic point of view, which would surely be an enormous task. What we will offer are reasons for doubting that the perversity view is defensible as a contemporary sexual ethic, since, as we have mentioned, this view sees much, if not most, contemporary sexual activity as immoral. That is, in the present chapter we will defend premise 3 of the formal argument found in the introduction.

Some Preliminary Considerations

One objection to the perversity view, which in all its forms recognizes a tight connection between morally permissible sexual relations and the possibility of procreation, is that very few Catholics hold this view. Obviously, this fact alone does not constitute a *refutation* of the perversity view, since the majority of Catholics could be wrong in their opposition to the perversity view; but it should nonetheless alert us to the possibility that the traditional view of sexual relations as being tightly connected to the opportunity for procreation is, at the very least, counterintuitive to most reflective and morally sensitive Catholics, and that it is, perhaps, misguided. As before, if morally permissible sexual relations have to be within marriage, with at least the possibility of children resulting from the sexual act, then a

great deal of (perhaps most) sexual activity that human beings engage in is immoral.

By definition, premarital sexual relations are immoral on the perversity view, since they are outside the bounds of marriage.[1] But is it clear that all premarital sexual relations are immoral? Cheap, one-night stands are immoral because one or both parties are using each other as sex machines rather than treating each other as dignified subjects, but is it as obvious as it once was that two unmarried people who care for one another, have agapic as well as erotic love for each other, and who exhibit such agape through sexual activity, are doing anything morally wrong? We think not. It is not necessarily the case that anyone is harmed by premarital sexual relations, much less that the premarital partners treat each other cruelly; and it is distinctly possible that the sexual partners actually enhance each other's moral lives.

Moreover, the use of contraceptive practices, *even within marriage,* would be immoral on perversity grounds. But is it as obvious as it once was that the sexual relationship between two people is cheapened (rendered cruel, in Augustine's terms) by the fact that the sexual relationship was engaged in for some reason other than procreation? We think not. No one is harmed when two married people who care for each other have sexual relations without the possibility of procreation present; and, in fact, such people may not only be pleased by, but morally enriched by, such sexual relations.

It should be emphasized that to morally permit some premarital sexual relations, and to do the same regarding contraceptive practices, is not to be committed to a "consenting adults" view of sexual relations. We do think that mutual consent is a necessary condition for a sexual act to be moral, in that if one of the sexual partners does not give consent, then he or (more likely) she would have been objectified and hence treated immorally. It is for this reason that rape and pedophilia are perhaps the most abominable sexual crimes. But to say that mutual consent is a necessary condition for morally permissible sexual relations is a far cry from saying that it is a sufficient condition. Something

in addition to *mutual consent* is required; namely, *mutual agapic respect,* as we will see.

No doubt some contemporary defenders of the perversity view will think that our mutual consent-mutual agapic respect view is too "permissive," but this charge is a knife that can cut both ways. By emphasizing, as defenders of the perversity view do, that what is crucial in moral sexual relations is that they be within marriage for the purpose of having children, there is a risk that mutual consent will be compromised. For example, there is a tendency in the perversity view to morally permit any sexual relations between married partners as long as there is at least the possibility of having children as a result of the sexual relations. That is, the strong link between sexual relations and procreation in the perversity view has made it possible to give only tepid approval to the idea that sexual relations can be an expression of, and partially constitute, conjugal love. But, according to the view we are defending, sexual relations within marriage with the possibility of children would be morally questionable if: (a) one of the partners exerted subtle psychological pressure on the other to have sexual relations; or if (b) the woman were treated (or was willing to treat herself) as a baby-producing machine. Neither of these possibilities need bother a defender of the perversity view. The perversity view is at once too restrictive (regarding premarital sex and regarding contraceptive practices) *and* too permissive (regarding, say, the near carte blanche it gives to married partners who might produce a fertilized egg).

We assume that, on the grounds of the perversity view, if one married partner wants to have children and the other does not, it would be moral for the former partner to badger the other, or otherwise engage in practices that do not indicate mutual, agapic respect, so that the other partner will give up contraception. After all, the key feature of the perversity view is the necessary link between sexual relations and procreation. Mutual, agapic respect may be encouraged, but on the perversity view it is not required.

It is not clear why contemporary Catholic sexual ethics should have to follow Augustine's notoriously negative attitude toward sexual relations, shaped as it was by his idiosyncratic personal

struggles.[2] And it is not clear that contemporary Catholic sexual ethics should have to exhibit a tendency, often found in dualism, to try to fly away from the body. For example, Thomas's hylomorphism provides the resources for a far more favorable view of sexual relations than any that could be developed on an Augustinian or dualistic basis. In hylomorphism, one's body is not easily conceived (as it is in dualism) as an occasion for sin or as an impediment to soul, but rather is the very vehicle through which there can be besouled agency in the world.

One of the reasons why a more positive attitude toward sexual activity has not developed in Catholicism—not even on a Thomistic, hylomorphic basis—is that it has been assumed that having children is a good thing. Indeed, it is a good thing. But not even good things are unqualifiedly good when they proliferate. There can be too much of a good thing. Hence, a pro-life stance—a stance that reflects the etymological roots of the word "proliferate"—can have negative consequences not often admitted by its defenders. Most notable among these consequences are the deleterious effects of exponential growth in the human population.

It must be admitted that the extent to which human population growth is a problem is to some extent a matter of debate, as can be seen if we contrast the positions of Tristram Coffin and Jacqueline Kasun.[3] Coffin exemplifies the "Doomsdayer" or "neo-Malthusian" approach, which is based on the claim that, whereas food production grows in a linear way (1, 2, 3, 4, 5, . . .), population grows exponentially (2, 4, 8, 16, 32, . . .). The effect of the latter sort of growth is that if a sum increases at 1 percent per year, it will double in size in 70 years; at 2 percent, it will increase fourfold in 70 years. The fact that population growth is indeed a problem is illustrated by the fact that at the time of Christ there were about 300 million people on the earth, whereas now the earth's population is around 5.6 *billion;* in fact, the population of the earth has doubled since 1956, when it was 2.8 billion. At the present rate of increase (1.8 percent), it will double again by around 2035, when there may well be 11 billion people.

By way of contrast, the Catholic Kasun exemplifies a "Cornucopian" approach, wherein our problems are alleged to be not

primarily demographic but moral and political. It is not our intent to reject Kasun's approach entirely, because if the United States, with approximately 5 percent of the world's population, uses a disproportionate amount of the world's natural resources and produces a disproportionate amount of its pollution, then much can be learned from what she says. Much can also be learned from advanced technologies that have enhanced food production. That is, the debate between Coffin and Kasun should not be seen as a zero-sum game in which if one side makes a good point, the other side's view is necessarily weakened.

The point we wish to make here is that even if there is much to be learned from Kasun's approach, Coffin's stance is nonetheless strong enough to make the case, and make it convincingly, that we no longer need to feel compelled to be fruitful and multiply: human beings have already done a very good job of that! Moral individuals, we take it, should be concerned at this stage in history not so much with increasing the number of members of our species—we now number in the billions—but rather with the quality of the lives human beings lead. Even if we could feed 5.6 or 11 billion people—which is a questionable assumption— it is by no means clear that we would be showing agapic respect to these people by leaving them a world aesthetically impoverished by overcrowding and environmentally degraded to the point where wilderness areas have all but vanished. Moreover, managed parks, which often amount to little more than tree farms, are not—as are old growth forests—conducive to the development of a critique of anthropocentrism, a critique crucial to any adequate defense of theocentrism (the belief that God is the center of things). That is, there are *religious,* as well as aesthetic, reasons to be in favor of population control, so as to make it more likely that human beings could understand their place in a divinely ordered natural world.

In short, in this section of the chapter we have tried to suggest, if not defend in detail, that the strong connection between moral sexual relations and procreation found in the perversity view is questionable, both because it rules out *a priori* certain types of sexual relations that are not clearly immoral (e.g., pre-

marital sex and contraceptive sex) and because it contributes to what is widely regarded as the huge social problem of overpopulation, especially in the poorest countries, some of which are Catholic.

Sex and the Human Telos

We would like to reiterate that in order to criticize the perversity view—the view that regards as immoral all sexual relations that sever the link between sexual intercourse, on the one hand, and marriage and procreation, on the other—one need not embrace the other extreme and defend a mutual consent view. Sometimes two adults can consent to do things that are immoral because they are disrespectful. For example, sexual intercourse between a sadist and a masochist might meet the mutual consent criterion (admittedly a necessary condition for moral sexual relations), but not the mutual, agapic respect criterion. In short, one does not always respect another by granting her what she wants.

By criticizing what we have called the perversity view, we are not committed to throwing away the concept of perversion. Rather, we are only committed to rejecting the view that all sexual relations outside marriage and without the possibility of procreation are perverse. An example of an activity that we think still deserves to be called "perverse" is provided by Thomas Nagel.[4] Imagine someone who enjoyed cooking and, so, took up reading cooking magazines. But also imagine this person eventually developing a fetish for the pictures of fine food in the magazines, such that she eventually grew to dislike eating real food and was only satisfied by ripping pages out of the magazines and devouring them! Surely this activity is perverse since it is not—on good biological and Aristotelian-Thomistic grounds—conducive to the fulfillment or the *telos* of the individual in question. It is perverse, in a word, because it is unnatural, and it is unnatural because it is destructive of a human being's fulfillment.

Likewise, just as there is not anything wrong with looking at food magazines, there is not anything wrong with viewing erotic

pictures. But if viewing these pictures becomes habitual, to the point where sexual relations with a dignified human being become difficult or impossible, then viewing the pictures would be perverse. Or if, as some allege, the pictures viewed depict violence, such that viewing them makes one more likely to be violent toward a sexual partner, then such activity can legitimately be called perverse in that it is unnatural; and it is unnatural because sexual violence is not conducive to the *telos* of a rational individual.

The overall point here is that there is significant room for the concept of sexual perversity in the mutual consent–mutual agapic respect view we are defending. But the perversity of sexual activity is not clearly tied to its disconnection from marriage and/ or procreation. On the view we are defending, marital sex can be moral (usually it is, we suspect, since the long-term commitment that marriage involves tends to foster mutual respect), but it can also be immoral (as in a famous court case a few years ago that raised the novel legal position of rape within marriage). That is, to loosen the connection between moral sexual relations and marriage does not imply abandonment of a sacramental view of marriage wherein the *best* sex is that which enriches a lifelong agapic commitment between two individuals.

It must be admitted that the ready availability of contraceptives, combined with the availability of abortion, may deprive sexual intercourse of spiritual meaning. But a rich spiritual life is not necessarily hindered by, and may actually be enhanced by, premarital sexual relations, which, as we have argued, can be either moral or immoral. That they often are immoral, due to certain temptations attendant on the transitoriness of premarital relations, should not be allowed to prejudice the fact that they *can* exhibit mutual consent and mutual agapic respect. Likewise, on the view we are defending, homosexual sexual relations can be moral or they can be immoral, if, for example, they involve sadomasochism.[5]

We would like to emphasize that nothing we have said conflicts with an Aristotelian view wherein the goal of sexual morality is to develop the dispositions or virtues that allow one

to reach the goal of human fulfillment or happiness (*eudai-monia*). This is a view recently defended in detail by the tradi-tionalist philosopher Roger Scruton.[6] In Scruton's Aristotelian version of sexual ethics, jealousy is one of the greatest impedi-ments to *eudaimonia*; hence, he thinks, it is in the deepest hu-man interest that we form the habit of fidelity, a habit that is strained by the very nature of sexual desire. Scruton is correct to criticize "Don Juanism," in which the project of intimacy (and of agapic mutual respect) is constantly abbreviated and hence distorted by the flight to another sexual object. Lust, like jeal-ousy, is a habit without sufficient regard for the personhood of the sexual partner; hence, sexual relations with a prostitute pro-vides him an ideal example of lustful objectification. By way of contrast, Scruton defends sexual relations that acknowledge the sanctity of the other's body as the tangible expression of another self worthy of respect.

Scruton is premature, however, in believing that in our current "libertarian culture" moral regress will occur when a contrast is drawn with "traditional sexual education." The cause of this re-gress lies in what he sees as a drift away from an Aristotelian view of sexual ethics, dominated as it was by certain virtues and vices, and a movement toward a Kantian view of the human subject. Scruton is worth taking seriously here, even if we think his care-fully argued position ultimately consists in a mischaracterization of a view of sexual ethics more liberal than his own.

Scruton's view is that traditional sexual morality was domi-nated by Aristotelian hylomorphism and a legitimate concern for the body. In his view, however, the Kantian position is heavily influenced by Cartesian dualism, so a Kantian concern for "purely personal respect" assigns no distinctive place for the body and, hence, leads to a "permissive" morality. For example, on the permissive Kantian view, according to Scruton, a sexual act is not sinful or immoral solely by reason of its being premari-tal or homosexual in character. But this ethic of liberation, he claims, does not release the self from hostile (bodily) bondage—as Cartesians and Kantians think—but heralds the "dissipation of the self in loveless fantasy."[7]

No doubt the mutual consent-mutual agapic respect view we are defending would strike Scruton as overly "Kantian" and insufficiently "Aristotelian," in his senses of these terms. Several comments are in order. First, we would emphasize that it is mutual *agapic* respect that we are claiming is one of the necessary conditions for moral sexual relations, a feature that we think enables us to avoid the disembodied formalism sometimes found in some versions of Kant's (and Kantian) ethics. Early Christian agape grew out of an earthy, Semitic, embodied concern for others. Second, it is precisely the sort of Aristotelian hylomorphism defended by Scruton that we used in chapters 2 and 3 above to counteract the deleterious effect of seventeenth-century dualism on the issue of the morality of abortion. We therefore see no need to abandon the notion of an embodied self when we examine issues in sexual ethics. And third, the difference between Scruton and other religious traditionalists and us regarding sexual ethics does not have to do with an abandonment on our part of the notion of an embodied self. Rather, it has more to do with the fact that Scruton and other traditionalists want to make judgments regarding the morality or immorality of a particular sexual act solely on the material basis of the act's being within marriage and without contraception being used. It is *this* materiality that leads Scruton to mischaracterize "libertarian culture" as conducive to disembodiment. On our mutual consent-mutual agapic respect view, by contrast, *some* sort of attention must be paid to intention and motive, no matter whether the sexual act in question is premarital, marital, or homosexual. This hardly commits one to an overly disembodied view because it is precisely the sexual partner's *body* that can be shown disrespect.

It might be objected that there is something a bit too quaint in using ancient or medieval hylomorphism to respond to contemporary moral problems. But as long as "hylomorphism" is taken in a wide sense to refer to the belief that matter (*hylē*) is always in-formed (*morphē*), we think it perfectly appropriate to use this doctrine to respond to the hegemony the dualism-reductionistic materialism debate has had on contemporary philosophy. As Alfred North Whitehead repeatedly pointed out decades

ago in his classic work, *Science and the Modern World*, dualism leads to reductionistic materialism in its own way once it is realized that, on the basis of dualism itself, most of the world is composed of inert, pliable matter, with only a few souls scattered about as ghosts in human bodies conceived as machines. Once the ghosts are exorcized, reductionistic materialism makes perfect sense. But there is a third option: the view that there is no inert, formless, or completely pliable matter, since *all* physical reality is in some way or other in-formed and value-laden, such that "pure matter" can be understood only by a bastardized sort of reasoning (as Plato and Aristotle realized) when it is seen as a conceptual limit never actually reached. Not even subatomic particles are totally devoid of some sort of self-motion and ability to respond to the world around them. This alternative to either dualism or reductionistic materialism can be seen in either Aristotelian or Thomistic terms, but it can also be seen in Whiteheadian terms. Indeed, several Whitehead scholars refer to Whitehead's view as a dynamic hylomorphism, in which *every* concrete singular exhibits *both* a "mental" or appetitive or experiential pole (especially prominent in human beings) and a physical pole (especially prominent, say, in the molecules that make up a rock). The latter pole consists in the degree to which a concrete singular receives causal inheritance from the past, and the former in the degree to which it can exert some sort of creative response to that past, however slight, in the future.

Conclusion

It is possible for the perversity view to be put into practice consistently, but only if its defenders notice that it has negative consequences for premarital sexual relations, sexual relations within marriages where contraception is practiced (it is unclear why the "rhythm method" should be an exception), postmenopausal sexual relations, and homosexual sexual relations, and that it might have to morally permit certain sexual relations within marriage where something less than mutual, agapic respect is present. The *possibility* of a consistent application of the

perversity view, however, should not hide the fact that even most religious traditionalists have in some way or other abandoned it; from a sociological perspective, it is at least interesting to notice that few contemporary Catholics still hold the perversity view, the view that disagrees with premise 3 in our argument stated in the introduction.

That is, although we have not claimed to have refuted the perversity view in this chapter, we do claim to have called into question the belief that it is the only possible view of sexual ethics a contemporary Catholic could hold, given the fact that most contemporary Catholics are somewhat embarrassed (as well they should be if they have been positively influenced—whether directly or indirectly—by Aristotelian/Thomistic dynamic hylomorphism) by the largely negative attitude toward sexual relations that the Catholic church has inherited from St. Augustine. Finally, even if there is the (remote) possibility of a consistent application of the perversity view in contemporary society, it is far from clear that a defender of this view can escape moral criticism when it is considered that the suffering brought about by overpopulation is due, in part, to the influential view that there is an integral link between morally permissible sexual relations and the possibility of procreation.

The perversity view is problematic for two additional reasons: (a) Sexual relations can be *immoral in* marriage even if the intent is procreation—for example, if there is no mutual consent or no agapic respect. (b) Sexual relations can be *moral outside of* marriage even if the intent of these relations is *not* procreation—for example, if the sexual relations (whether heterosexual or homosexual) are expressive not only of consent but also of agapic respect. Contemporary Catholics can do better than to continue to believe in the perversity view.

Appendix: The Perversity View in Historical Context

From the perspective of the view we are defending, it is crucial to note that Catholic teaching on abortion is not governed by papal infallibility and that Catholic history on abortion reveals

inconsistencies and unresolved tensions, as is emphasized by Jane Hurst.[8] Our goals in the present chapter have been to separate morally permissible sexual relations from the intent to conceive children and to further explicate the Catholic history of abortion, a history that has been, and still is, largely unknown by laypersons and intellectuals alike. Most people who know anything at all about the Catholic view of abortion assume that the church's current position is the result of almost two thousand years of unchanged teaching; but, in reality, there never has been a unanimous view on abortion in Catholicism among philosophers or theologians. Contraception, abortion, and infanticide were widely practiced in the Roman Empire. Early Christianity had to negotiate its way between the sexual permissiveness of the Romans and the sexual negativity of the Gnostics, who saw the soul as imprisoned in the body so that there was no value to be found in sexual activity or procreation. Indeed, the Gnostics prohibited marriage and held virginity as an ideal. Hence, in one sense, the dominant view of sexual ethics that developed in Catholicism was a moderate view between these two extremes. Our critique in this chapter, however, has in effect been an attempt to counteract the negative effects of the residual Gnosticism found both in Augustine's view of sexual relations and in the tremendous influence his view has had on the history of Catholic sexual ethics.

Broadly conceived, dynamic hylomorphism, we have argued, has favorable implications not only for the view that abortion is permissible in the early stages of pregnancy but also for a view of sexual ethics more defensible than Augustine's. In the centuries between Augustine and Thomas there was no standardized system of penances, which were instead determined on a local basis. In the seventh-century Irish Canons, for example, the penance for illicit sexual relations with a woman was seven years on bread and water, unless she was a neighbor, in which case the penance was fourteen years; but the penance for abortion was only three and a half years. Or again, the eighth-century penances attributed to Bede have the woman who has an abortion early in pregnancy do penance for one year, but a late-term abortion

makes her a murderess. It was not until the twelfth century that Gratian compiled the first collection of canon law that was accepted as authoritative; and he saw abortion as homicide only when the fetus was formed—a view affirmed by several thirteenth-century writers, as we have seen.[9]

It is hard not to notice that before the seventeenth century the dominant view in Catholicism was that abortion, if early, was not homicide. And the reason for this is that delayed hominization was at least implied, and in some cases explicitly affirmed, in St. Jerome, St. Augustine, Cyril of Alexandria, Peter Lombard, St. Anselm, St. Bonaventure, St. Thomas Aquinas, the Council of Vienne, and the Council of Trent. The only notable exceptions in the Western Church seem to have been the first-century *Didachē* (which was not discovered, however, until the nineteenth century and hence was not a major shaper of Catholic tradition) and, as we have noted, some passages in Tertullian. (A few authors who condemn abortion are vague regarding whether their condemnation involves an abandonment of delayed hominization: e.g., the "Letter of Barnabas," Athenagoras.) After the seventeenth century, however, the dominant view shifted to immediate hominization, which is at least implied, and in some cases explicitly affirmed, by St. Alphonsus of Ligouri, Jean Gury, the Code of Canon Law (1917), numerous popes (including Paul VI and John Paul II), et cetera. We have tried to account for this transition in chapter 2, and to indicate why it is important for Messenger, de Dorlodot, Häring, Donceel, and others to remind us of the more traditional (and, we think, defensible) view found in delayed hominization.

A possible counterexample to our thesis in chapter 2 is the case of Pope Sixtus V, who in 1588 declared that abortion at any stage was homicide. But it is worth noting that Sixtus took this stand because of his concern about the prevalence of prostitution in Rome: by imposing severe penalties for abortion, he hoped to diminish *sexual sin*. By 1591, however, Gregory XIV returned to the theory of delayed hominization, which was not *formally* called into question until 1869 by Pius IX and later, in 1917, in the new Code of Canon Law. In between the dominance of de-

layed hominization and the dominance of immediate hominization, we claim, was the erroneous belief in a homunculus, a belief that is at least indirectly responsible for the fact that, while throughout most of the history of Catholicism the abortion issue was largely a matter of disinterest, defenders of the ontological view have now made it into something of a Holy Crusade.[10] Some defenders of the ontological view even compare abortion to the Holocaust, a comparison that we think is problematic both because it exaggerates the ontological status of the early fetus and because it trivializes the ontological status of the Jews, Slavs, and others who were killed in the concentration camps. In that Catholics were not in the forefront of opposition to the concentration camps, Catholics should be especially reluctant to use such comparisons.

Even today, however, there is no consistent application of immediate hominization in Catholicism, even among the opponents of abortion. Fetal baptisms are not always performed on miscarriages, and funeral masses are seldom said even when a full-term fetus is stillborn. What has remained constant in Catholicism, until recently, is the strong connection between sexual relations and procreation, so the view we have defended in this chapter is admittedly less firmly rooted in the tradition than our defense of delayed hominization. But it is to be hoped that we are living through a period in history when Catholics are moving beyond the questionable understanding of sexual relations reflected in the perversity view. Most Catholics now believe that sexual relations are, or should be, more a part of an agapic relationship, including the sexual partners themselves and God, than a procreative duty. Sexual relations can serve the development of persons and can be creative (can serve to achieve one's *telos*) as well as procreative in character. It is to be hoped that this more reflective view of sexual relations can be combined with a defensible view of fetal development, so as to call into question the aura of infallibility, if not an actual claim to infallibility, found in contemporary Catholic opposition to abortion.[11] Some Catholics are prone to fundamentalism of office, just as some Protestants are prone to fundamentalism of the book. We can do better.

The insistence in early Christianity on the firm link between sexual relations and procreation in part derives from the influence of the Stoics as well as from the Gnostics. Throughout the history of Catholicism, this link has resulted in a failure to recognize much of a connection between sexual pleasure, on the one hand, and agapic love and human fulfillment, on the other. Thankfully, the link now seems to be breaking up. Even if viewing abortion as a sin of sex were defensible, it would not be an appropriate basis for legislative denial in a democratic, pluralistic society, as we will see in the following chapter. But the perversity view is not defensible because its defenders have never adequately indicated *why* sexual activity necessarily involves a type of immoral pleasure that can only be redeemed by its subordination to procreation.[12]

We would like to make it clear that the more positive view of sexual ethics that we think could be developed on Thomistic, hylomorphic grounds, rather than on Augustinian ones, should not be taken to imply that Thomas's own views on the subject are much better than Augustine's. They are not. Thomas not only views lust as a mortal sin, he thinks that the "inordinate discharge of semen" is a sin that is the second worst. Only murder is worse, he thinks![13] Unlike his defense of delayed hominization, this view strikes us as implausible, at best.

CHAPTER 5

Catholicism and Liberalism

IN THIS CHAPTER WE WOULD LIKE to explore the relationship between the view of abortion we have defended in this book and the political ramifications of this view as they would be felt in a pluralistic democracy. We will be especially concerned with showing how the view we are defending is, in addition to being a Catholic one, an explicitly liberal view of abortion, and how other Catholic views of abortion are also at least compatible with liberal political institutions, which serve as an umbrella under which all reasonable views can be protected.

We will rely on the most important contemporary liberal political philosopher, John Rawls, who makes what we take to be a crucial distinction between comprehensive liberalism, or relativism, on the one hand, and political liberalism, on the other. The latter is compatible with—in fact, it is conducive to the flourishing of—Catholicism in a modern pluralistic society. We will be relying not only on Rawls's classic, *A Theory of Justice*, but also on his more recent *Political Liberalism*. A consideration of this latter work will enable us later in the chapter to correct some misconceptions of Rawls's political liberalism in several thinkers who are in different ways at least somewhat opposed to Rawlsian liberalism in light of a Catholic approach to abortion: Stanley Hauerwas, Lisa Sowle Cahill (two important contemporary theo-

logians), and in a quite different way Philip Quinn (an important contemporary philosopher of religion). It is our view that in *Political Liberalism* Rawls expands on great liberal Catholic thinkers like Jacques Maritain and John Courtney Murray, a fact that is admitted (albeit reluctantly) by several contemporary Catholic thinkers such as David Hollenbach, S.J., and Louis Dupré.

In the past twenty-five years, three familiar (and seemingly inconsistent) criticisms have been leveled by Catholics and other traditionalists or communitarians against the thought of John Rawls and other liberal political philosophers. On the one hand, Rawls's thought is alleged to be overly individualistic. Stephen R. L. Clark's way of putting the point is to say that debates in Rawls's original position are engaged in by "self-serving" individuals.[1] On the other hand, it is alleged that the original position with its veil of ignorance is impossible: "My principal criticism of this model . . . is that no such debate is strictly conceivable. Once put us behind such a veil and we can have no idea at all what we would prefer to do or have done. There is no value-neutral body of law, and no real human persons not embedded in particular historical and personal circumstances. There are no abstract individuals."[2] That is, Clark is skeptical as to whether any real human society can result from disconnected, deracinated strangers.[3] A third familiar criticism made by Catholics and other traditionalists or communitarians regarding Rawls's thought and regarding liberalism is that the individualism fostered by Rawls leads to some sort of relativism, in that no particular ideal of how to live should be promoted or protected over any other.[4] This is a view that, if true, would be disastrous regarding the issue of abortion.

Alasdair MacIntyre makes these three points in terms different from those used by Clark, but the result is much the same. For Rawls, according to MacIntyre:

> a society is composed of individuals, each with his or her own interest, who then have to come together and formulate common rules of life. . . . [The] only constraints are those that a prudent rationality would impose. Individuals are thus . . . primary and society secondary, and the identification of individual interests is

prior to, and independent of, the construction of any moral or social bonds between them. But . . . the notion of desert [justice] is at home only in the context of a community whose primary bond is a shared understanding both of the good for man and of the good of that community and where individuals identify their primary interests with reference to those goods.[5]

Other traditionalists or communitarians could be cited who make similar criticisms. If accurate, such criticisms suggest that the Rawlsian, liberal individualist would probably not even be interested in listening to, much less be convinced by, the arguments of opponents to abortion to the effect that liberalism is incompatible with Catholicism.

We will argue that these criticisms of Rawls affect most strongly the articulation of the Rawlsian position in his 1958 article "Justice as Fairness," that Rawls to some extent avoids these criticisms in *A Theory of Justice* (1971), and that he avoids them almost entirely in his most recent book, *Political Liberalism* (1993). That is, we will be arguing that Rawls's thought has become less and less susceptible to these criticisms that would, in fact, be significant ones were they to be effective.

The present chapter is obviously not meant as a complete political philosophy. Rather, we will be concentrating on these three points because a liberal view of abortion is often seen to be at odds with Catholic opposition to abortion in that the former is alleged to be too individualistic, too relativistic, and so abstract that it precludes the appropriation of tradition that is central to Catholic thinking. In response, we will try to vindicate Rawls's political liberalism and a liberal Catholic view of abortion regarding these three charges.

It should be noted that the well-known traditionalist or communitarian critiques of Rawls offered by Catholics were developed before the publication of *Political Liberalism*. We will show that these criticisms are not as telling as they were before the publication of this book, so that they should be either modified or dropped. Our intent here is to show that a careful treatment of the details of Rawls's development can eventually serve to clarify the relationship between liberalism and abortion. At the same

time, we will also argue that Catholic traditionalists or communitarians are correct in criticizing the view of rights as "absolute" and as connected to a selfish or self-interested anthropology, but that they are incorrect in thinking that political liberalism needs to view rights in this way. In short, the overall objective in what follows will be to argue that one can be a liberal, a Catholic, and a qualified supporter of the morality of abortion.

"Justice as Fairness"

In his early article with this title, Rawls notes the connection between his theory of justice as fairness (which is embodied in his now famous two principles)[6] and the ancient sophistical notion of justice. Both conceptions see justice as a "compromise between persons of roughly equal power who would enforce their will on each other if they could, but who, in view of the equality of forces amongst them and for the sake of their own peace and security, acknowledge certain forms of conduct insofar as prudence seems to require. Justice is thought of as a pact between rational agents the stability of which is dependent on a balance of power and a similarity of circumstances."[7] Rawls notes that the best known statement of this conception is that given by Glaucon at the beginning of Book Two of Plato's *Republic*.[8] Rawls's view does not completely coincide with this conception, although it is close to it. For example, Rawls does not think that this conception of justice is tied to a quality of "manic egoism," as he thinks Plato does.[9] Nor does Rawls want to be interpreted as assuming a general theory of motivation. When he refers to parties as self-interested, he is only referring to their conduct and motives as they are taken for granted in cases where questions of justice ordinarily arise.[10] For Rawls, justice is the virtue of practices where there are assumed to be competing interests and conflicting claims. In a community of saints, disputes about justice, including disputes about abortion, would hardly occur at all. But abortion *is* a disputed issue, so there is a need, we think, for liberal political procedures to adjudicate the conflicting claims made with regard to its morality.

Although Rawls does not want to be interpreted as assuming a general theory of motivation, it should be noted, first, that in this early article he does see justice as a compromise, or as what he will later call a modus vivendi; and second, that the parties who engage in this compromise would, in fact, enforce their wills on each other if they could. Despite his intention to avoid rational egoism, Rawls has opened himself to Clark's and MacIntyre's first and second criticisms of his position, and perhaps to the third as well.

A Theory of Justice

In this book no connection between Rawls's own theory and Glaucon's position is drawn or alluded to. Rawls still believes that the parties in the hypothetical social contract (now called the "original position") need not be egoists, although he adds that they are mutually disinterested.[11] That is, egoism is attributable to individuals who are interested in wealth, prestige, domination, and the like. Mutual disinterest only entails not taking an interest in one another's interest, such that in choosing between principles the parties in the original position try as best they can to advance their own interests.[12] This is not an example of egoism because once the veil of ignorance is removed, these parties may not want (for religious or other reasons) more goods, or more liberty, or more of their interests advanced.[13] Rawls is only suggesting that, from the standpoint of the original position, it is reasonable to suppose that they do want a larger share; they can refuse it later. This clarification of what is meant by self-interest (or mutual disinterest) is an advance over "Justice as Fairness" and constitutes an important step in the effort to avoid the Catholic traditionalist's or communitarian's critiques, including those of Catholic opponents to abortion. More precisely, it is simply not true that political liberals—including those who would morally permit abortion in the early stages of pregnancy—have to adopt an anthropology of self-interest that is thoroughgoing; they only need assume for the sake of method that reasonable contractors will look out for their own interests.

Rawls contends in *A Theory of Justice* that for a problem regarding justice to arise at least one party must want to do something other than whatever everyone else wants to do. That is, justice as fairness (the phrase still applies) assumes that human beings are not *perfect* altruists (a view that is compatible with the Christian idea of original sin).[14] This seems to imply that the parties are *somewhat* altruistic and have some type of commitment to the common good; that is, they are willing to act justly even if they are not willing to abandon their interests, which further removes Rawls from the vulnerable position he articulated in "Justice as Fairness."[15] A society in which there are no conflicting demands at all is such a utopian one that it is not really a just society, but lies beyond justice. Rawls seems to think that the society described by Socrates, in response to Glaucon, is such a trans-just society; and, presumably, Clark and MacIntyre would defend Socrates (Plato) against Glaucon (and Rawls in "Justice as Fairness"). Rawls uses the notion of a "private society" to describe the visions of one like Plato who imagines a Republic in his own mind's eye.[16]

Nevertheless, there is still a great deal of continuity between "Justice as Fairness" and *A Theory of Justice.* For Rawls, the structure of teleological arguments (those that postulate *the* goal of politics) is radically misconceived. From the start they attempt to define the common good or reveal human nature through human aims, rather than attempting to discover the principles we would acknowledge to govern the background conditions under which these aims are to be formed.[17] In short, justice (or "the right") is still prior to the common good (except the "thin" notion of the good presupposed in the original position).[18] Plato's failure to give priority to the right is evidenced, Rawls thinks, by his advocating the "noble lie" in the *Republic,* a device that violates the publicity required in the original position.[19]

If we return to Book Two of the *Republic,* we can get at the root of the difference between Rawls and traditionalists or communitarians, including many Catholic opponents of abortion. Glaucon distinguishes among three different sorts of goods: (a) those that are good for their own sake, but not for their effects

(e.g., joy); (b) those that are good both for their own sake and for their effects (e.g., health); and (c) those that are good for their effects, but not in themselves (e.g., a bad-tasting medicine taken to cure an illness). This third sort of entity, although laborious and painful, is endured reluctantly for its rewards. In which class should justice be placed? For Plato, and presumably for Clark and MacIntyre, justice belongs to the second class. But for Glaucon, and presumably for Rawls in "Justice as Fairness," justice belongs to the third class. This can be inferred from Rawls's previously cited contention that justice is a compromise between persons who would enforce their wills on each other if they could. This compromise is reluctantly entered into when we realize that we are not living among saints. In other words, for Rawls in "Justice as Fairness" (and in *A Theory of Justice*?) there is nothing intrinsically worthwhile in justice; his notion of justice is what MacIntyre would call a mere "external good."[20] It more closely resembles a medicine (sometimes painful) needed to cure an illness than the intrinsic worth found in health.

With this discussion as a background, we will now mention three problem areas that may be found in Rawls's theory in "Justice as Fairness" and, to a lesser degree, in *A Theory of Justice*, from a Catholic traditionalist or Catholic communitarian point of view.

a. Rawls's contention that the right (or the just) is prior to the good becomes suspect when he has to introduce his "thin" notion of the good into the original position. Catholic traditionalists or communitarians may rightly wonder how one could determine which primary goods are essential for a just society without a general theory of the good being assumed from the outset. The answer to this concern remains unclear throughout *A Theory of Justice*. This need not mean, however, that for Rawls the good is prior to the just; but it does indicate that a theory of the common good plays a far more important role in Rawls's theory than is admitted in "Justice as Fairness" and *A Theory of Justice*.

b. It is not clear why, if justice is so reluctantly entered into, one would enter into the original position at all if one were in a position of power, no matter how slight an advantage this might

provide. As Glaucon suggests in the Gyges' ring story, the prime reason why justice is viewed so reluctantly is that the best situation would be that in which one could do as one wanted with impunity. If one is in any sort of favorable position, there would be no reason to be just if justice were good only for its effects, which is what Rawls seems to imply in "Justice as Fairness" and to a lesser extent in *A Theory of Justice.* If this is not what Rawls intends, then he would seem to be in far more agreement with Socrates or Plato or Clark or MacIntyre than with Glaucon, contra his position in "Justice as Fairness."

c. Although Rawls does not want to defend any general theory of self-interested motivation, it seems that the only way he can avoid doing so is by suggesting that there is something inherently worthwhile or ennobling about justice, as Catholic traditionalists or communitarians rightly emphasize. Otherwise, the only apparent reason for being just would be to obtain the effects that justice brings, which would thereby make Rawls's view closer than he would like to a utilitarian position. But if Rawls admitted that there was something inherently good about justice, then he would not (à la Glaucon) view being just reluctantly. It may be that there is more value in what Rawls calls the "perfectionist" position than he admits in *A Theory of Justice.*[21]

In short, Rawls's own allusion in "Justice as Fairness" to the similarities between his position and Glaucon's makes one wonder if his theory of justice in *A Theory of Justice* can avoid being: (a) more intimately connected with a theory of the common good than is admitted; (b) anathema to those who have some degree of power and wealth, since justice seems to be valued largely, if not exclusively, for its effects; and (c) involved in a conflict between what seems to be Rawls's notion of justice as something reluctantly assented to *and* Rawls's disavowal of his theory being based on an anthropology of self-interest.

Political Liberalism

Turn now to Rawls's latest work, a book that continues the move, initiated in *A Theory of Justice,* away from the view of

justice as a mere compromise made by parties who would enforce their wills on each other if they could. *A Theory of Justice* clarifies the point that Rawlsian self-interest is largely a methodological or procedural device associated with the original position, and is not a part of a comprehensive anthropology. It is clear from this book that if one assumes that human beings are not *perfect* altruists, one can still assume that they are *somewhat* altruistic. But more work needs to be done to avoid Catholic traditionalist or Catholic communitarian criticisms, work that is done well in *Political Liberalism.*

Rawls is well aware that he will be accused by political traditionalists or communitarians of defending egoism on grounds similar to those used by Schopenhauer against Kant. If we cannot will a social world in which others are always indifferent to our pleas, then it seems that the autonomy required in the original position is but a disguised heteronomy where we literally get our moral principles from the authority of others; and morality is always at least partially conditioned by what others think. The key to responding to this objection is to regard as reasonable the procedure for arriving at justice as an external constraint and not as derived from an essential feature of human persons. But if the procedure for arriving at justice is viewed as an external constraint, then it can only be accepted "cunningly" (Rawls's word) as a compromise. In *Political Liberalism,* however, Rawls makes it clear that he views the procedure for arriving at justice *not* as an external constraint but as a result of human beings being reasonable. Rawls does not remind us of his own earlier view as including a (cunning) compromise. But, given the criteria of *Political Liberalism,* Rawls should view his earlier position in these terms.[22]

By hypothesis, the parties in the original position have no direct interests other than their own and those of the parties they represent. Hence, they are not being egoistic or too individualistic, as Catholic traditionalists or communitarians allege, by representing these interests. The constraints imposed on the parties in the original position are internal to them *as reasonable agents of construction.* These constraints are the reasonable

and formal conditions implicit in their moral power to be just. The constraints in *Political Liberalism* are not derived from our supposed natural inclination to overcome our finite nature, as Schopenhauer claimed. Exercising our moral power to be reasonable and just *is* one of our higher-order interests. Once again, the constraints imposed in the original position are ultimately not external but internal.[23]

Rawls uses the phrase "modus vivendi" in *Political Liberalism* to characterize a treaty between two states or individuals whose aims and interests put them at odds, as in the abortion debate. (The phrase seems to refer to something equivalent to the compromise position defended by Rawls in "Justice as Fairness.") It is not advantageous for either side to violate the modus vivendi. But should conditions change, they might do so, since a modus vivendi only provides an apparent social (or international) unity. The stability provided by a "mere" (Rawls's word) modus vivendi is contingent on circumstances that do not upset the convergence of interests that occurs by happenstance, rather than by any deep agreement between those whose interests are at odds. In *Political Liberalism* Rawls does not wish to defend a modus vivendi or a compromise position, but rather a more permanent "overlapping consensus," which is something "quite different." Consensus itself is a moral concept, rather than a mere convergence of self- or group-interests. We start with our own comprehensive religious, philosophical, or moral grounds—*including views on abortion*—but once we realize that there are a plurality of reasonable religious, philosophical, or moral views, the stage is set for a serious consideration of consensus as a concept in morality.[24] That is, political liberalism's handling of the abortion debate should result, *at the very least,* in a modus vivendi, but it is also possible that the contending parties might eventually reach an overlapping consensus.

It is not the job of Rawlsian social contract theory to account for the rise of political liberalism. But Rawls treats at least one historical example that sheds light on the reasonableness of contemporary political liberalism, especially when the contentious abortion debate is considered. In the sixteenth century there was

no overlapping consensus regarding the principle of toleration between Catholics and Protestants; only a modus vivendi obtained, in that each side was convinced that it was a ruler's duty to uphold the true religion and to punish heresy.[25] Rawls's mistake in "Justice as Fairness," and to a lesser extent in *A Theory of Justice,* was to confuse the initial, reluctant acceptance of a modus vivendi, as the only workable alternative to endless civil strife, with what might eventually develop when a just constitutional consensus was itself affirmed. Political liberalism and the concept of justice it fosters are compatible with comprehensive religious views like Catholicism and Protestantism, and with comprehensive moral views like Kantianism and utilitarianism, even if it is not necessarily derived from them. Reasonable people can come to see the principle of justice that underlies political liberalism as worthy of affirmation in itself, regardless of whether it is a big part of their more comprehensive religious or philosophical or moral views—including their views of abortion. It is a historical fact that the acceptance of the principle of justice that governs the liberal state as a modus vivendi gave way to the more positive acceptance of it in terms of an overlapping consensus. This fact can now inform the way reasonable people view justice. Guaranteeing basic political liberties to people takes them off the political agenda and beyond the calculus of social interests; and it is reasonable to insist on such a guarantee, regardless of one's comprehensive religious, philosophical, or moral views.[26]

It may be objected by Catholic traditionalists or communitarians that Rawlsian procedural fairness is not substantive; it has no content, since is not tied to any view of the human *telos.* Put differently, liberalism as procedural fairness is too "thin" in itself as a conception of justice. To some extent we agree with this criticism, since, as we have noted, Rawls's notion of the good is (unwittingly) a bit thicker than he is sometimes willing to admit. But our overall point here is that procedural fairness, although not a sufficient condition for an adequate theory of justice, is nonetheless a necessary condition for the development an adequate theory of justice and for an overlapping, moral con-

sensus that yields a "thicker" conception than that found in *A Theory of Justice.*

Trust in a reasonable principle of liberal justice, that is, a principle of procedural fairness, increases when our fundamental interests are more firmly and willingly recognized by others. Concomitant with this increase is a modification of the comprehensive religious, philosophical, and moral views of reasonable persons: simple pluralism moves toward reasonable pluralism, which is conducive to a constitutional consensus and eventually to a moral, overlapping consensus. This is because the "comprehensive" religious, philosophical, and moral views of most people are not fully comprehensive, so that there is a region available for the development of an "independent allegiance" to a moral concept that can bring about consensus; namely, a trust and confidence that others will acknowledge basic liberties.[27]

It is true that each "comprehensive" view is related to the concept of justice in political liberalism in a different way. This concept can be deduced from Kantianism, and it is a working approximation of utilitarian principles. That is, the political liberalism defended by Rawls is not to be equated with relativism. Further, political liberalism is at least compatible with religious ethics. In fact, as a result of the religious wars, it is actually welcomed by many religious believers, except perhaps those who are rigid fundamentalists (a redundancy, it seems). Kantians, utilitarians, relativists, and religious believers alike can endorse liberal justice, as can reasonable people with different views about abortion. In each case one must, within some "comprehensive" view or other, adjust to what is to be expected as the long-run outcome of the work of human reason under free institutions; namely, reasonable pluralism.[28]

An Attempt at Impartiality

It should now be clear that the most recent articulation of Rawls's view contains a concerted effort to avoid the criticisms made by Catholic traditionalists that his position is too individualistic. And it should also be clear by now how Rawls can respond

to the Catholic traditionalist or communitarian charge of relativism. Along with other liberals, Rawls is indeed a relativist *in the sense that* many different "comprehensive" religious, philosophical, and moral views—including views on abortion—are compatible with the concept of liberal political justice that is affirmed by reasonable individuals. But Rawls's view obviously has some nonrelativistic features, because not all "comprehensive" views are compatible with liberal justice, for example, those that flatly contradict political virtues such as toleration of reasonable differences and those for which human autonomy and equality in all forms are anathema. Rawls's famous two principles are testimony to the fact that some political views are to be promoted more than others. He is hardly a relativist in any strong sense of the term.

Finally, Rawls has clarified his view regarding the charge made by Catholic traditionalists or communitarians that the original position is impossible because there are no deracinated, abstract individuals, but only concrete ones with what Rawls refers to as "comprehensive" religious, philosophical, or moral views that have implications for one's stance regarding abortion. One of the major aims of *Political Liberalism*, however, is to show that despite the fact that human beings have relatively comprehensive religious, philosophical, or moral views, it is now widely recognized that it is not reasonable to have anyone's (not even one's own!) "comprehensive" moral view dictate *simpliciter* the basic political structure. That is, it is now widely recognized that, given reasonable pluralism, the only way to have one "comprehensive" view reign supreme over others is to force it down people's throats or, perhaps, to make use of Plato's "noble" lie.

In order to achieve the impartiality required by the original position, one need not utterly deny that one has a particular ethnic or religious or cultural background that informs one's "comprehensive" view. A particular individual can move in the direction of greater impartiality or objectivity or reasonableness by abstracting from his or her specific position in the world without really losing that specific position. Participants in the original position are asked to engage in *methodological* abstraction,

so as to objectively determine principles of justice. Without *some* move away from one's own "comprehensive" view, one is left with a tendentious opinion rather than with philosophical justification, but this is not to deny the concrete embeddedness of individual human perspective.

Still, it must be admitted that there is some accuracy in Clark's and MacIntyre's belief that there is a danger in liberalism, since it can be interpreted in such a way that it can strip us of everything interesting and distinctive and basic to morality. But Rawls does not play into Clark's and MacIntyre's hands here, even if Thomas Nagel perhaps does. Nagel sees us pulled simultaneously in two different directions: toward the subjective and particular and toward the objective and impartial. The latter pull he identifies with a view of ourselves *sub specie aeternitatis*. This is the view outside of time and space traditionally associated with divine omniscience. It is a view, as Nagel admits, from "nowhere." Hence, a Clark-like or MacIntyre-like critique of it is likely to succeed, since no one is from nowhere. Rawls, too, refers to his *hypothetical* original position as a view *sub specie aeternitatis;* but this is clearly a mislabeling, in that he does not mean a view from nowhere or from some spot outside of time and history. Rather, he says the following in *A Theory of Justice:*

> Without conflating all persons into one but recognizing them as distinct and separate [the original position] enables us to be impartial, even between persons who are not contemporaries but who belong to many generations. Thus to see our place in society from the perspective of this position is to see it *sub specie aeternitatis:* it is to regard the human situation not only from all social but also from all temporal points of view. The perspective of eternity is not a perspective from a certain place beyond the world, nor the point of view of a transcendental being, rather it is a certain form of thought and feeling that rational persons can adopt within the world. And having done so, they can, whatever their generation, bring together into one scheme all individual perspectives and arrive together at regulative principles that can be affirmed by everyone as he lives by them, each from his own standpoint. Purity of heart, if one could attain it, would be to see clearly and to act with grace and self-command from this point of view.[29]

Clearly, this is not so much a view of the world from the perspective of eternity—whatever that might mean—as an attempt, within temporal process, to place ourselves altruistically in the shoes of those in other places and times.

Rawls argues that we are embodied and historical human beings who are embedded in strong traditions like Catholicism. Hence, he can avoid many of the critiques from Catholic traditionalists or communitarians, and from certain feminists, who are skeptical of disembodiment and abstraction in ethics. Rawls is correct that *it is always a concrete being who engages in abstract political reasoning.* We hold on Rawlsian grounds that we need to consider as many points of view of other embodied and historical beings as possible, including those of our opponents—whoever they may be—in the abortion debate. It seems to us that one should not egoistically cling only to one's own view, as Clark and MacIntyre allege Rawls does, nor claim that one can adopt a stance outside of all points of view, as Nagel seems to do.[30] If our reconstruction is correct, Clark's and MacIntyre's criticisms largely do not apply to Rawls's mature position. Rawls's political liberalism is a moderate position between Clark's and MacIntyre's excessive concern for particularity and Nagel's excessive conception of what it takes to be impartial.

A useful summary of some of the key notions in *Political Liberalism* can be found in the following quotation, which we assume applies both when there is moral disagreement among citizens *and* when they agree about moral values (e.g., honest opponents in the abortion debate all agree that all human persons should be valued), but not about factual questions (e.g., regarding which scientific information is relevant when determining when fetal life should be seen in personal terms):

> One difficulty is that public reason often allows more than one reasonable answer to any particular question. . . . Should this happen, as it often does, some may say that public reason fails to resolve the question, in which case citizens may legitimately invoke principles appealing to nonpolitical values to resolve it in a way they find satisfactory. . . . The ideal of public reason urges us not to do this in cases of constitutional essentials and matters of ba-

sic justice. . . . [A]bandoning public reason whenever disagreement occurs in balancing values is in effect to abandon it altogether. Moreover . . . public reason does not ask us to accept the very same principles of justice, but rather to conduct our fundamental discussions in terms of what we regard as a political conception. We should sincerely think that our view of the matter is based on political values everyone can reasonably be expected to endorse. For an electorate thus to conduct itself is a high ideal the following of which realizes fundamental democratic values not to be abandoned simply because full agreement does not obtain.[31]

Overconfidence in appeals to nonpolitical, religious values is due to the unwarranted assumption that if political values are ultimately grounded in a divine source (as they definitely are in a theistic view of the world) then any appeal to public reason or to political values themselves is inadequate. But to think that political values have some further backing does not imply that we cannot accept these values in their own right.

The point here is that politics in a democratic society can never be guided by what any one citizen or any one group sees as "the whole truth." The legitimacy of a democratic society does not come from "the whole truth," but from the fact that in it people can live with others in light of reasons all might reasonably be expected to endorse. There are no Rawlsian obstacles to the religious belief that there is divine backing to certain political values (e.g., the belief that each person is a dignified subject worthy of respect). The present book, however, has made it clear that, in the near future, there will not likely be agreement among reasonable people, *or even among reasonable Catholics,* that the fetus in the early stages of pregnancy is a person who is a dignified subject worthy of respect. Our view is that the obvious value of the pregnant woman as a dignified subject overrides whatever minimal value the early fetus has. In fact, it would be cruel to deny a pregnant woman the right to an early abortion except in the cases of rape or incest, since she can be treated cruelly, whereas the early fetus cannot. As Rawls puts it with reference to abortion, "we would go against the ideal of public reason if we voted from a comprehensive doctrine that denied this right."[32]

The public reason in political liberalism does not ask citizens

to excise their religious convictions, so as to start from scratch in moral deliberation, because this sort of procedure would violate the very idea of an overlapping consensus. The Rawlsian key is to make sure that our "comprehensive" doctrines are reasonable in the sense that they allow a certain leeway, such that we can accept—even at times reluctantly—the conclusions of public reason if they are the result of a fair decision-making procedure that aims at impartiality. Such decision-making procedure is, at the very least, a necessary condition for politically resolving the abortion debate, even if it is not a sufficient one.

Abortion and Criticism of Political Liberalism

The strengths of Rawls's approach can be put in sharp relief, we think, when we consider his critics. For example, Stanley Hauerwas has apparently given up altogether on reasonable argumentation concerning the abortion debate. He thinks the arguments and counterarguments on abortion are well known, and no one is likely to change his or her view of the matter; so not much is to be gained by rational argumentation on abortion in a liberal context. Moreover, Hauerwas seems committed to the belief that "the very character" of debate in a liberal, pluralistic society by its nature leads to irresolvable conflicts. That is, liberalism, on his view, is equated with relativism, or with comprehensive liberalism, rather than with the more modest, and the more defensible, Rawlsian political or methodological or procedural liberalism. By equating liberalism with relativism, Hauerwas has made it a bit too easy to contrast the classical view of human nature, wherein the central concern was how to realize the human good, with the modern view, wherein the central concern is how we can prevent each other from interfering with our private concerns. Hauerwas seems to prefer the former view, especially because its narrative structure avoids the deracinated, abstract features of the modern one.[33]

It should be clear from what we have said above regarding Rawls's *Political Liberalism*, however, that not only are individuals in a liberal society *allowed* to develop virtuous lives along the narrative lines defended by Hauerwas, they are *encouraged* to do

so *as long as* their views of virtue do not conflict with what rea-
sonable individuals would agree to within the confines of a fair
decision-making procedure that aims at impartiality. Rawls is not
a complete proceduralist, but a moderate one. That is, Rawls
would agree with Hauerwas that for a liberal state to work, some
sort of "comprehensive" view—say, the classical view—has to be
presupposed by each citizen in the effort to regulate the lives of
individuals. A liberal society need not, as Hauerwas assumes, be
antithetical to what he calls our "Christian ambitions." As we
see things, these "ambitions" should include a much wider and
deeper understanding of the history of delayed hominization
within Christianity, a history with which Hauerwas seems to be
bored. To take this history seriously is not to abandon Hauerwas's
commendable belief that children represent our continuing com-
mitment to live as a historic people, because a fetus in the early
stages of pregnancy cannot meaningfully be described as a "child."
Daniel Maguire is correct to point out that "Where there is doubt,
there is freedom" (*Ubi dubium, ibi libertas*). This is the theologi-
cal notion of probabilism in Catholicism, wherein a doubtful
moral obligation may not be imposed as though it were certain.
The fact of reasonable doubt is exhibited by certain obvious mis-
takes made in the past, as when religious freedom was not owed
to non-Catholics or when no interest-taking on a loan could be
moral. Today, we are claiming against Hauerwas, there is reason-
able doubt regarding abortion.[34]

Lisa Sowle Cahill does not share Hauerwas's position regard-
ing the status of fetal life, because she sees this question as the
"most fundamental" one of all. This is a view that, as we have
seen, is typical of Catholic views of abortion in general. We agree
with her, against Hauerwas, on this point, and we also agree with
her "developmentalist" approach wherein the value of the fetus
increases incrementally throughout gestation. But Cahill does
not see the development of sentiency as a morally relevant
threshold, as we do; in fact, she sees the fetus as having a value
at conception that is quite significant. To justify abortion even
early in pregnancy, she thinks that "serious considerations" must
occur. But, then, we are not sure about what to make of the fol-

lowing: "Few are unfamiliar with the attempts of some prolife advocates to substitute enlarged photographs of aborted fetuses for rational argument. More subtle are the efforts of prochoice proponents to eliminate critical recognition of the matter-spirit link in abortion."[35] Her point here seems to be that those who defend a "pro-choice" stance pay insufficient attention to the linkage between matter (once again, *hylē*) and mind (spirit) contained in, say, a dynamic hylomorphism. But it should now be clear how a consistent application of dynamic hylomorphism does, in fact, support a less exalted view of the ontological status of the fetus in the early stages of pregnancy than is defended by Cahill.

Despite the fact that Cahill rejects Hauerwas's disinterest in the question of the status of the fetus, she does agree with him that the issue of abortion includes historically conditioned communal values and commitments not included in the "liberal ethos," an ethos that she thinks should be superseded. (By "liberal ethos" we assume she means the overly abstract version of liberalism defended by Nagel, as described above.) For example: "the virtue of hope embodied in inauspicious situations enables the perception of at least a *prima facie* obligation to sustain fetal life, even if that life is not clearly of equal value to postnatal human life. Indeed, this takes us far from the position that it must be demonstrated beyond a reasonable doubt that the fetus is a 'person' in the full sense of the word as a precondition for according it protection."[36] Two points should be noted here, however. First, there is nothing in Rawlsian political liberalism that prohibits members of historically conditioned communities from having hopes; but the concept of hope by its very nature involves future contingencies not yet actualized, as was seen above in chapter 3. More precisely, the fact that members of certain communities hope that the fetus will be carried to term does not imply that the fetus in the early stages of pregnancy is already the bearer of moral rights. Or, at least, it would be difficult to get reasonable, impartial persons in the original position to agree that fetuses have such rights. And second, even Cahill admits, in her carefully nuanced view, that the fetus in the early stages of preg-

nancy is only the recipient of a prima facie obligation on our part, an obligation that, presumably, could be trumped by other considerations—by our obligations to others, for example.

Perhaps some sort of rapprochement is possible when it is realized that liberals need not be complete proceduralists. *Along with Rawls,* Hauerwas and Cahill have criticized comprehensive liberalism or relativism, because some set of moral views is needed to deal with all of the issues in life that are not matters of political disagreement and that are, instead, part of an individual's or a community's quest for virtue. But unlike Hauerwas or Cahill, Rawls is clear that there is a large difference between comprehensive liberalism or relativism, on the one hand, and procedural or methodological or political liberalism, on the other, a distinction that is quite ironically presupposed by Hauerwas and Cahill when, in other places, they freely state views that might be considered heterodox in some circles. (For example, we assume that Hauerwas and Cahill defend liberal values like freedom of speech.) One of us, at least, is not as pessimistic as Hauerwas or Cahill regarding the possibility of Rawlsian overlapping consensus. For example, such a consensus already exists among Catholics and other religious believers regarding the principle of toleration itself. Few, if any, Catholics these days believe, as did Thomas Aquinas, that heretics who did not mend their ways should be *killed!*[37]

The strength of Rawls's view can be seen when even his critics end up agreeing with him concerning some crucial issues in political philosophy. Consider the Catholic thinkers anthologized in a recent volume titled *Catholicism and Liberalism.* R. Bruce Douglass holds that "progressive" Catholics are often at odds with non-Catholic (e.g., Rawlsian) "progressives." But Douglass admits that, because of the difference principle, Rawlsian liberalism is more compatible with the common good tradition in Catholicism than are some earlier, and more individualistic, liberalisms. Or again, Douglass contends that liberalism, broadly conceived, breeds a private way of construing human good, but Rawlsian liberalism, he admits, is not unambiguously bourgeois. In fact, although not all Catholics call themselves "liberals," few

of them in the contemporary period hold views at odds with the liberal, Rawlsian standpoint. Likewise, David Hollenbach, S.J., criticizes Rawls for holding that the ultimate good in human life is a private affair, and for holding that "thick" theories of the good should be privatized. But Hollenbach admits that the Rawlsian difference principle has affinities to Catholic social theory, and that Rawlsian political freedom is now widely seen in Catholicism as an essential expression of human dignity. He also concedes that debates about the common good—including debates on abortion, we might add—must rely on Rawlsian "public reason." And Louis Dupré (who, by the way, defends delayed hominization), despite the fact that he thinks that economic progress plays too large a role in Rawls, nonetheless insists that Rawls escapes the relativism of many other contemporary thinkers, and that procedural fairness is crucial in political philosophy as long as its *telos* is a good-in-itself (*bonum honestum*). That is, he thinks procedural fairness does not so much replace concern for the common good as it provides a method by which the common good can be understood and explicated. We agree with Dupré on this important point. The common good among rational beings is imperfectly understood if it excludes, whether knowingly or not, the legitimate interests of some individuals or groups; procedural fairness is a check against such exclusion.[38] All three of these thinkers end up agreeing with Rawls on some crucial issues in political philosophy that bear on the abortion debate. They highlight a point that we think is essential: procedural fairness, although not a sufficient condition for a just society or for the common good, is nonetheless necessary.

In contrast to Hauerwas and Cahill, Ronald Dworkin both explicitly identifies with a form of political liberalism and explicitly treats the implications of time as asymmetrical for the abortion debate. His view is therefore worthy of notice given our position in chapter 3. We might initially think that it is automatically a greater waste of life if a young individual dies rather than an old one. But on the basis of this principle, an early-stage abortion would be morally worse than a late-stage one, a conclusion with which almost all parties in the abortion debate would dis-

agree. Likewise, it is terrible when an infant dies, but worse, most people think, when a three-year-old child dies, and worse still when an adolescent dies: "Most people's sense of . . . tragedy, if it were rendered as a graph relating the degree of tragedy to the age at which death occurs, would slope upward from birth to some point in late childhood or early adolescence, then follow a flat line until at least very early middle age, and then slope [down-ward] again toward old age. Richard's murder of the princes in the Tower could have no parallel, for horror, in any act of infanticide."[39] The death of an adolescent is worse than earlier deaths because this death frustrates the ambitions, expectations, hopes, and investments she had in her life, in addition to the hopes others had for her. The badness in part depends on the frustration of desire that occurs, but only after there is such desire.

If a late-term abortion is not as bad as infanticide, but is nonetheless worse than an early-term abortion, and this is due to the presence of sentiency in the late-term fetus, the question arises: how bad can an early-term abortion be? In Dworkin's reasoning, not so bad that the biological life of an early fetus cannot be "frustrated" in order to avoid later "frustration" to that life or to the lives of others. Even those who hold what we have referred to as the ontological view often agree with this move—when they permit abortion in order to save the life of, or preserve the health of, the mother, or, for example, to end a pregnancy that began in rape or incest. The moral question is whether abortion may be morally permissible in other circumstances. The political question is whether reasonable persons in a fair decision-making procedure would prohibit all other abortions. In the Rawlsian original position, one would have to imagine—*per impossibile*—that one was a pre-sentient cluster of cells, even though there is no self-awareness at this stage, as well as imagine that one was a pregnant woman under less than desirable, perhaps even drastic, circumstances. Given these conditions, we think, Rawls's own view of the permissibility of early abortion in a pluralistic, liberal state is secure.

One more critic of Rawls should be considered, so as to indicate further the complexity of the relationship between abortion

and pluralistic democracy and, once again, to emphasize the strength of Rawls's (or Dworkin's) approach to this issue. Philip Quinn might not initially seem to be in disagreement with Rawls when we see him permit abortion in the first trimester, but he wonders whether the public reason Rawls defends can establish this conclusion. Quinn's dispute with Rawls is an internecine debate between two liberals who would permit abortion in the early stages of pregnancy. Some versions of political liberalism exclude the religious from the public forum and some put forward a more inclusive ideal. Quinn defends the latter position, along with Kent Greenawalt, Michael Perry, Robert M. Adams, and Jeremy Waldron.[40] According to this inclusivist view, there is no good reason to exclude religious beliefs as a basis for political choice, and this for two reasons.

First, not only is Quinn skeptical that there will ever be a single comprehensive ethical theory all will agree to but he is also skeptical that an overlapping consensus is possible. (One of us largely agrees with Quinn here; the other shares Rawls's long-term optimism regarding overlapping consensus.) Advocating a religious view in the public forum, therefore, does not destroy a realistic possibility for overlapping consensus that would otherwise exist. Second, one's own comprehensive view, whatever it may be, may be improved through contact and confrontation with what other people really think if the reasons for their moral beliefs are religious in character, especially if what they think is alien to one's own way of thinking. And people's deepest ethical or political values often are embedded in religious beliefs, so that these ought to be heard.

Two comments are in order here. First, as we have mentioned above, there may be more reliable grounds for Rawlsian optimism regarding overlapping consensus than Quinn pessimistically thinks. Whereas toleration was not a virtue that was particularly important to the medievals, there is now in many countries an overlapping consensus—even among most religious believers within traditions that were once at each other's throats —that there should be basic constitutional guarantees regarding freedom of religion for all. Further, among various groups in

many countries there is now an overlapping consensus to the effect that basic constitutional guarantees should be granted to all persons, regardless of class, race, and gender, whereas there was not such an overlapping consensus a century ago. And it is not unreasonable to hope, provided we take a long-range view, that we are moving toward such an overlapping consensus in most countries. The United Nations Declaration of Human Rights, for example, is a document that has received at least nominal assent from all the member countries.

To be sure, too aggressive intrusion of certain religious beliefs into the public forum can be divisive rather than conducive to productive dialectical exchange. A case in point is the rather unproductive and dangerous attempts of some on the religious right in the contemporary United States to legislate their view of morality and truth for everyone else, not only regarding abortion but also regarding creation "science," divorce, school prayer, sex education, and so forth. The issue here is not that our "comprehensive" moral or religious views are at odds with those of the religious right, though they often are. It is rather that even when we largely agree with them—concerning, say, the permanence of marriage, which we support on both religious grounds and Kantian ones involving the serious nature of promises—we do not think that in the forum of public reason our views on the permanence of marriage should be made normative, because we know that many, perhaps most, reasonable people have views that do not overlap with our own on this matter. Still, it is probably the case that the most extreme on the religious right, in contrast to most religious traditionalists, are too closed-minded to promote the sort of overlapping consensus that is the basis of a genuinely pluralistic, democratic society.

Second, there is room within a Rawlsian framework for some appeals to religious grounds, as Quinn himself notices. As a result, Rawls's view can either be seen as semi-exclusionist or semi-inclusionist, depending on which aspect of his thought one wishes to emphasize. The appeals to religious grounds that Rawls thinks are compatible with public reason are those that, with suitable translation efforts, can be understood and agreed to by

reasonable moral agents outside of the particular religion that provides its adherents with a "comprehensive" moral view. For example, the abolitionists based their arguments to eliminate slavery on religious grounds, and Martin Luther King often framed his appeals in a religious way. But when King talked of his dream that one day all of God's children, black and white, would walk together in a discrimination-free society, it was not only believers within Christianity who could understand and agree with him but also believers in other religions and, indeed, agnostics and atheists. King's language resonated with reasonable agnostics and atheists because of the overlap between his view and whatever "comprehensive" view may have been embraced by the reasonable people who listened to him. By way of contrast, those who oppose abortion on either ontological or perversity grounds do not resonate with nonbelievers—or even with their fellow religious believers who hold to delayed hominization in the manner of Augustine and Thomas Aquinas. Those who hold the ontological view and say that God breathes a rational soul into a fertilized egg or into a two-week old fetus just baffle most of their listeners. Appeal to a "comprehensive" doctrine is appropriate in the political arena if it strengthens, or at least does not go against, the ideal of public reason; but most people find immediate hominization unreasonable.

Appeals to a "comprehensive" doctrine eventually have to be translated into the terms of public reason if one is serious about respecting the dignity of one's fellow citizens. Attempts on the part of opponents to abortion to base their view on genetic evidence is a step in this direction, but reasonable people are not generally convinced that such a basis is sufficient to condemn abortion in the early stages of pregnancy. And if there are not sufficient grounds within public reason for condemning abortion in the early stages of pregnancy, then the religious opponent to abortion should not simply assume that a religious basis for doing so, *if* such there be, can trump public reason. Indeed, Rawls himself stresses not so much the distinction between religious reasons and secular ones but rather the distinction between nonpublic reasons and public ones. This distinction allows us to

avoid a systematic exclusion of the religious, but it also imposes limits on appeals to the religious when they cannot be articulated convincingly to reasonable people of good will. Ontological opponents of abortion, we claim, are convincing neither in terms of public reason nor in terms of dynamic hylomorphism. And the inability of ontological opponents of abortion to make their case convincingly on general religious grounds, or on Catholic grounds in particular, should make them more circumspect in imposing their view on a diverse, polyglot, and pluralistic population.

Quinn is correct to point out that, on Rawlsian grounds, we should show restraint not only with respect to "comprehensive" views that support ontological opposition to abortion but also with respect to "comprehensive" views that permit abortion in the early stages of pregnancy, *but only if* such views do not strengthen public reason. That is, we need not resist "comprehensive" views that *do* support public reason. Because of his moderate position on the relationship between "comprehensive" moral views that are religious and public reason—neither totally severing the two nor giving a carte blanche to religious zealots—and because of the current existence of, and reasonable hope for, future progress in expanding overlapping consensus, Rawls's view is an appealing one.

It is to the credit of politically liberal institutions that they have recently functioned well—in the United States and in several other countries—regarding abortion rights for women. The majority opinion in the Supreme Court decision in *Roe v. Wade*, written by Justice Harry Blackmun, is compatible with much of what we have argued in this book. Until 1973, nontherapeutic abortion was illegal in most of the United States, even though until the late nineteenth century women had a broad right to terminate a pregnancy, since the issue of abortion was not firmly established in common law. But in 1973, the *Roe v. Wade* majority opinion declared that laws prohibiting abortion during the first twenty-four weeks of pregnancy were unconstitutional. Defenders of the majority opinion in this case arrived at this date because at that time viability is possible.[41] In the years since *Roe v. Wade*, not only has the date for viability not been pushed back

any further, it is not likely in the future that it will be pushed back further, because the development of a central nervous system, and therefore sentiency and viability, at least seem to be integrally connected; both occur around the same time, as we have seen. At the same time, *Roe v. Wade* clearly does not give women an absolute right to privacy or to an abortion, since it claims that the state does have the right to regulate abortions late in pregnancy, even if some abortions may be permitted late in pregnancy to preserve the life of, or the health of, the mother.[42]

One final remark should be made about the idea of autonomy. Just as there is a difference between comprehensive liberalism (or relativism) and political liberalism, so also there is a corresponding difference between a belief in comprehensive autonomy and a belief in political autonomy. It is the latter element in each of these contrasts that we are defending. Political autonomy refers to the quite legitimate freedom of human beings to vote as they see fit and to profess the religious beliefs that they consider appropriate in that in a just democratic society apostasy and heresy should not be seen as political crimes. This is a far cry from a belief in comprehensive autonomy. Religious believers, including those who are politically liberal, may very well believe that regarding our comprehensive religious beliefs we are ultimately dependent on God.

Afterword:

The Argument from

Marginal Cases

JOHN NOONAN HAS CLAIMED THAT the experience of pain has little attraction for the "pro-abortion party."[1] Nothing could be further from the truth. However, Noonan is instructive in the way he draws a comparison between the pain of fetuses and the pain of nonhuman animals. If the latter deserve our moral attention, he seems to be saying, so do the former. Suppose we agree with Noonan that we should define pain (*dolor*) as did St. Thomas Aquinas as the deprivation of a good *together with* perception of the deprivation.[2] Given this definition, Noonan attributes pain to the fetus because of the presence of "sense receptors" before the end of the second month. By sense receptors he means, we assume, cells that react to electrical and other stimuli or that engage in "evasive action" following the intrusion of pressure or light. But such cellular activity fails to constitute sentiency per se, the sort of sentiency that makes possible the experience of pain. If such activity did constitute sentiency per se, then single-celled organisms and plants would deserve moral respect, since they, too, would be sentient and capable of experiencing pain.

The purpose of this afterword is to take Noonan seriously regarding the comparison of fetuses with nonhuman animals, a comparison that, as we have seen, has roots within Catholicism with Augustine and Thomas Aquinas. This comparison will pro-

ceed by way of an important type of reasoning—arguing from marginal cases—found in antiquity in Porphyry and in contemporary philosophy.[3]

The Argument from Marginal Cases

Let us begin by distinguishing between moral agency and moral patiency. The former refers to being able to make moral decisions and to be held accountable for one's actions; the latter refers to being able to receive a moral or immoral action, such that one can be said to be harmed or be treated cruelly. The criterion essential for moral agency is relatively unproblematic; almost everyone agrees that rationality is a necessary condition for being a moral agent. There may be disagreements about whether or not a particular individual is rational (Lenny in Steinbeck's *Of Mice and Men*, for example), but there is not much disagreement with rationality as a necessary criterion for moral agency.

But what criterion needs to be met in order to be a moral patient? Catholic thinkers have generally, and correctly, balked at making rationality the operative criterion here, because to do so would seem to indicate that the marginal cases of humanity do not deserve moral respect. By "marginal cases" we mean those human beings who are not rational: infants, the severely retarded, the senile, the comatose, and others who are mentally enfeebled. The point to the argument from marginal cases is to claim that if we wish to protect all human persons, as all Catholic thinkers wish to do, then a criterion lower than rationality must be used, with sentiency being the most likely candidate. Between a high criterion for moral patiency (e.g., rationality) and a lower one (e.g., sentiency) lies another one, namely, the potential for rationality. However, this criterion is still too high if we wish to protect *all* humans, because although infants have the potential for rationality, severely retarded human beings do not. In short, if either rationality or the potential for rationality is the criterion for moral patiency, then highly counterintuitive and morally untenable conclusions follow, since in either case a great number of human beings would not be moral patients; thus, they

would be available for exploitation, experimentation, or manipulation as parts of some crude utilitarian calculus.

In short, a consistent application of the principle that only rational human beings deserve moral respect could lead to the mistreatment of many human beings, for example, in medical experiments where marginal cases of humanity might be exploited for use in painful trials. No Catholic thinker can seriously consider rationality as the criterion for moral standing, for moral patiency. At the same time, however, one can also create serious moral problems by making the criterion for moral standing too low. For instance, if one claimed, in the manner of Albert Schweitzer, that all life deserved moral respect, then plants could have rights and it might turn out that we would have little, if anything, to eat. And if one were consistently "pro-life," one would have to show (*per impossible*) moral respect for paramecia, insects, tissue excised during a medical operation, cancer cells, asparagus, and so on. Harvesting carrots, on a consistent pro-life hypothesis, would constitute something of a massacre, we suppose.

No doubt ontological opponents to abortion will say at this point that they are not so much "pro-life" as they are "pro-human life," but this move begs the question here as to what is meant by the term "human." All can agree that even a fertilized egg is human in the sense that it has human parents and a human genetic code. But we contend that neither a fertilized egg nor the fetus in the early stages of pregnancy is human in a *morally significant* sense. And we have noteworthy support for this view from Catholic tradition, for as we have seen, both Augustine and Thomas Aquinas argue that a fetus in early stages of pregnancy has a moral status best described in vegetative terms.

Two different sorts of sentiency should be distinguished here, both to illustrate the argument from marginal cases and to adequately respond to Noonan's invitation, mentioned above, to compare fetuses with nonhuman animals. "Sentiency per se" refers to sentiency as the term is normally used, namely to the ability of beings with central nervous systems to *feel pain* and, in Thomistic terms, to *perceive* (though not necessarily conceive)

the deprivation of some good. "Proto-sentiency" refers merely to automatic responses to stimuli found in individual cells. The problem with Noonan's attribution of pain to fetuses as early as the fifty-sixth day of pregnancy—long before individual cells are connected to the cerebral cortex and long before synapses start to appear—is that he is actually referring to proto-sentiency rather than to sentiency per se. By contrast, animals actually experience pain, because they are sentient per se, and this is because their central nervous systems are sufficiently well-developed so that they *can* experience pain. We do not think that proto-sentiency is all that significant from a moral point of view; if it were, then cancer cells and paramecia and cells in plants would have moral standing. But no reasonable person can consistently act as if these beings were moral patients—Albert Schweitzer, Sidney Callahan in her feminist opposition to abortion, and members of the Jain sect not withstanding. The sort of sentiency that is morally significant, we have argued, is sentiency per se, which is exhibited by animals, both human and nonhuman, and by late-term fetuses.

The argument from marginal cases may be stated in more formal terms, as follows: If a being has morally relevant characteristics a, b, c (e.g., sentiency) . . . n, but lacks autonomy or reason or the sophisticated use of language, and a human being outside of the womb has characteristics a, b, c (e.g., sentiency) . . . n, but lacks autonomy or reason or sophisticated language use, then we have as much reason to believe that the former is a moral patient as the latter. Thus, if the latter (marginal human beings) are moral patients, then nonhuman animals and fetuses in the later stages of pregnancy are moral patients as well. And, indeed, "marginal" human beings do deserve moral respect according to all Catholic thinkers, so that nonhuman animals and fetuses late in pregnancy also deserve moral respect, with some even thinking that they have rights. The argument from marginal cases may be referred to as the "argument for moral consistency." Stephen R. L. Clark, the religious traditionalist discussed above in chapter 5, is right to be bothered by the commonly used label "marginal" as it is applied to some human beings when it is realized that

such humans *do* have standing as moral patients. Perhaps we should instead call them "non-standard" human beings, because this designation seems a bit less likely to leave them on the moral periphery.

The key point is that any morally relevant characteristic possessed by *all* human beings outside the womb will not be possessed *only* by human beings outside the womb. For example, all humans outside the womb feel pain (even human beings in a coma have functioning central nervous systems, as do those who are anesthetized or who have various nervous disorders), but it is not only human beings outside the womb who feel pain. Animals and late-term fetuses are also sentient per se. While only human beings outside of the womb can solve quadratic equations, not all human beings can do this. What makes us moral patients is something more basic than rationality or even the potential for rationality.

By concentrating in this book on the moral permissibility of abortion in the early stages of pregnancy, and generally prohibiting them after the development of sentiency, we do not mean to imply that there are no important moral problems regarding late-term abortions. Even ontological opponents of abortion permit some late-term abortions, notably those under *in extremis* conditions where the mother's life is in danger, even if these abortions must meet the criteria of the principle of "double effect." In simple terms, this principle says that the death of a fetus may be foreseen in such an abortion, but it is not intended, just as the death of a person will be foreseen, but not intended, if there are two persons stuck in a burning building but only one can be rescued. For the most part, we agree with this view; but we also think that the same sort of reasoning can be extended to cover late-term abortions in order to preserve the health and well-being of a pregnant woman if carrying the fetus to term would seriously endanger her health or well-being. And we are also open to the possibility of a late abortion that is morally permissible when it is known that, if the fetus were born, an infant would come into the world with severe, life-diminishing, and painful deformities. Here abortion should be permissible, but only if it is for the good

of the sentient fetus to be aborted rather than for the financial good or convenience of others. These are difficult matters that we will not explore in any detail, because an adequate treatment of moral patients under *in extremis* conditions would require another book. The point we wish to make here is that these are exceptions to the rule prohibiting late abortions, which are, we think, at least on prima facie grounds, immoral.[4]

In this book we have attempted to retrieve a traditional argument; but we have done so in a way that differs from that of some other thinkers who claim to defend delayed hominization, thinkers whose position is barely distinguishable from what we have referred to as near immediate hominization. That is, the crucial issue, as we see things, is not when a zygote becomes an individual, since we readily grant that it is an individual *something*; the question is when it becomes the sort of individual who can be consistently seen as a moral patient. And *this* question, we think, is best answered in terms of the argument from marginal cases. Hence, the detailed debate between defenders of immediate hominization on the basis of a zygote being *individuum* (literally, not divided) in both a biological and an ontological/moral sense, such as Mark Johnson,[5] and those who defend near-immediate hominization or a weak version of delayed hominization on the basis of exactly when in the first few weeks of pregnancy the zygote or embryo becomes a distinct, individual organism,[6] is really a debate among immediate hominization theorists.

We conclude by reiterating a point we made above in chapter 3: to say that a fetus that acquires a functioning central nervous system late in pregnancy has a moral status similar to that of a nonhuman animal is to say something significant about such a fetus. In response to—but also in partial agreement with—Noonan, we emphasize that *any* being that can experience pain ought not to be forced to experience pain or be killed unnecessarily or gratuitously. Pre-sentient fetuses, however, are not yet capable of experiencing pain or of being harmed, as Augustine and Thomas Aquinas well knew. (Only if fertilized eggs were sentient would it make sense to insist on bringing them to term with volunteer mothers. This has actually been proposed by

some ontological opponents to abortion in a recent case in Britain involving three thousand fertilized eggs that had been frozen for over five years. Such a ridiculous proposal is not only consistent with ontological opposition to abortion but is necessitated by it.)[7] And we nonmarginal human beings can experience pain both physically and psychologically, and we experience the latter because of our advanced rationality. We would do well at this point to remember Jesus' words found in Matthew (10:28) to the effect that God cares even for the fall of a sparrow, but "you" are of more value than many sparrows. Presumably the "you" here refers to those with the capacity for rationality who heard what Jesus said, since it is hard to believe that Jesus was referring to (early) fetuses.

Notes

Introduction

1. See Daniel Callahan, "The Roman Catholic Position," in *Abortion: A Reader*, ed. Lloyd Steffen (Cleveland: Pilgrim Press, 1996).

2. See Marjorie Reiley Maguire, "Personhood, Covenant, and Abortion," in *Abortion: A Reader*, ed. Lloyd Steffen (Cleveland: Pilgrim Press, 1996).

3. Josiah Royce, *The Philosophy of Loyalty* (New York: Macmillan, 1908), p. 11.

4. See, e.g., Daniel Maguire, "Abortion: A Question of Catholic Honesty," in *Abortion: A Reader*, ed. Lloyd Steffen (Cleveland: Pilgrim Press, 1996); and several articles by Joseph Donceel, S.J.: "A Liberal Catholic's View," in *Abortion in a Changing World*, ed. Robert Hall (New York: Columbia University Press, 1970); "Abortion: Mediate v. Immediate Animation," *Continuum* 5 (1967); and the magisterial "Immediate Animation and Delayed Hominization," *Theological Studies* 31 (1970).

5. On the interest principle see Joel Feinberg and Barbara Baum Levenbook, "Abortion," in *Matters of Life and Death*, ed. Tom Regan (New York: McGraw-Hill, 1993); Bonnie Steinbock, *Life before Birth* (New York: Oxford University Press, 1992); and K. J. S. Anand and P. R. Hickey, "Pain and Its Effects in the Human Neonate and Fetus," *New England Journal of Medicine* 317, no. 21 (Nov. 19, 1987).

6. See Bruce Carlson, *Patten's Foundations of Embryology*, 6th ed. (New York: McGraw-Hill, 1996); Keith Moore, *Essentials of Human Embryology* (Philadelphia: Decker, 1988); and Steven Oppenheimer and

George Lefevre, *Introduction to Embryonic Development*, 3d ed. (Englewood Cliffs, N.J.: Prentice-Hall, 1988).

7. See Harold Morowitz and James Trefil, *The Facts of Life: Science and the Abortion Controversy* (New York: Oxford University Press, 1992), and Clifford Grobstein, *Science and the Unborn* (New York: Basic Books, 1988).

8. Don Marquis has recently defended the claim that nonsentient fetuses can have interests, but Marquis admits that "interest" is an equivocal term, referring both to actively *being interested in* or *taking an interest in* something, on the one hand, and something being in a certain individual's interest without that individual realizing it, on the other. Early fetuses do not have interests in the former sense. See "Can Nonsentient Fetuses Have Interests?" paper delivered at the American Philosophical Association–Central Convention, 1998. Also see Laura Westra, "The Abortion Issue: A Non-Anthropocentric Perspective," forthcoming.

Chapter 1: Cruel Lust

1. John Noonan, "An Almost Absolute Value in History," in *The Morality of Abortion*, ed. John Noonan (Cambridge: Harvard University Press, 1970). Also see Paul Carrick, *Medical Ethics in Antiquity* (Boston: D. Reidel, 1985). Regarding the reasons for condemnation of abortion in early Christianity (see below), there is another possibility. Perhaps the early Christians lumped together abortion and infanticide, were horrified by the latter, and hence forbade the former as well; the *Didachē* from the first century A.D. prohibits both, but without supporting reasons.

2. James McCartney, "Some Roman Catholic Concepts of Person and Their Implications for the Ontological Status of the Unborn," in *Abortion and the Status of the Fetus* (Boston: D. Reidel, 1983), p. 313. McCartney relies here on Susan Teft Nicholson, *Abortion and the Roman Catholic Church* (Knoxville: Religious Ethics, 1978). Cf. Beverly Wildung Harrison, "Theology and Morality of Procreative Choice," in *On Moral Medicine*, ed. Stephen E. Lammers and Allen Verhey (Grand Rapids, Mich.: Eerdmans, 1987), p. 432.

3. Noonan, "Almost Absolute Value," p. 51.

4. See Daniel Dombrowski, "The Virtue of Boldness," *Spirituality Today* 37 (1985).

5. Michael Gorman, *Abortion and the Early Church* (New York: Paulist Press, 1982), pp. 70–72.

6. Noonan, "Almost Absolute Value," pp. 16, 44.

7. John Connery, S.J., *Abortion: The Development of the Roman*

Catholic Perspective (Chicago: Loyola University Press, 1977), pp. 55–59, 212.

8. Augustine, *On Marriage and Concupiscence.* See an English translation in Philip Schaff, ed., Nicene and Post-Nicene Fathers, vol. 5 (Grand Rapids, Mich.: Eerdmans, 1956). And vol. 10 of Sancti Aureli Augustini, *Opera Omnia,* ed. J.-P. Migne (Paris, 1861–65).

9. See Augustine's *Against Julian* in The Fathers of the Church series, vol. 35 (New York: Fathers of the Church, 1957). And vol. 10 of Sancti Aureli Augustini, *Opera Omnia,* ed. J.-P. Migne (Paris, 1861–65).

10. On Augustine's notion of original sin see Daniel Dombrowski, "Starnes on Augustine's Theory of Infancy: A Piagetian Critique," *Augustinian Studies* 11 (1980). Also see "The Confessions of Augustine and DeQuincey," *Augustinian Studies* 18 (1987).

11. Augustine, *The City of God,* in Nicene and Post-Nicene Fathers, vol. 2 (Grand Rapids, Mich.: Eerdmans, 1956). And *De Civitate Dei,* vol. 7 in Sancti Aureli Augustini, *Opera Omnia,* ed. J.-P. Migne (Paris, 1861–65).

12. Augustine, *Enchiridion.* Nicene and Post-Nicene Fathers, vol. 3. And vol. 6 of Sancti Aureli Augustini, *Opera Omnia,* ed. J.-P. Migne (Paris, 1861–65).

13. As far as we know, there is no English translation of Augustine's *Quaestionum in Heptateuchum..* See vol. 34 of Patrologiae Cursus Completus, Series Latina, ed. J.-P. Migne (Paris, 1845).

14. "Where in truth the birth is unformed the question of homicide is not pertinent. . . . and therefore it is not homicide. . . . therefore the law of homicide is not pertinent."

15. See, e.g., Donceel's "Liberal Catholic's View."

16. "Because it is not yet possible to speak of soul living in a body destitute of sensation, if such a kind is not formed in flesh, it is therefore not endowed with sensation." The point here seems to be that certain physical developments ("formed in flesh") are required for sensation to occur, and sensation (sentiency) is required for a human soul to be infused into the fetus.

17. It should be noted, however, that it would be very difficult to find *any* contemporary interpreter who would defend Augustine on this particular point. See the religious traditionalist Terry Miethe, *Augustinian Bibliography, 1970–1980* (Westport, Conn.: Greenwood Press, 1982), p. 208: "by today's standards, even among the most . . . conservative Christians . . . Augustine's view of sex in marriage is not acceptable on Biblical or other grounds."

18. See Daniel Dombrowski, *Christian Pacifism* (Philadelphia: Temple University Press, 1991). Also see *Summa Theologiae,* 2a2ae, question 64, article 6.

19. See Donceel's "Liberal Catholic's View."

20. For Aristotle's views of fetal development see his *Generation of Animals*, Loeb ed. (Cambridge: Harvard University Press, 1953), esp. book 2, chaps. 1–4. Also see *Politics*, book 7, chap. 16; and *History of Animals*, book 7, chap. 3. On Aristotle's influence in Catholicism see Uta Ranke-Heinemann, *Eunuchs for the Kingdom of Heaven* (New York: Doubleday, 1990), pp. 74, 249, 305.

21. See the following texts from Thomas: *Summa Theologiae*, Blackfriars edition with Latin and English (New York: McGraw-Hill, 1970), 1a, question 118, articles 1–3; *On the Truth of the Catholic Faith* (New York: Hanover House, 1955), book 2, chaps. 88–89, and the Latin edition, *Summa Contra Gentiles* (Rome: Marietti, 1961); and *On the Power of God* (Westminster, Md.: Newman Press, 1952), question 3, articles 9–12. Also see Thomas's early work *Scriptum super libros sententiarum* (Paris: Lethielleux, 1929–47), 2, d. 18, question 2, article 3; and *In omnes S. Pauli Apostoli Epistolas* (Turin: Marietti, 1929), I, p. 388—*I ad Corinthos*, lectio 1. Finally, see *Summa Theologiae*, 1a, question 115, article 2; 2a2ae, question 154, article 2; 3a, question 28, article 1.

22. Thomas, *Summa Theologiae*, 1a, question 118, article 2.

23. Ibid., article 3.

24. Thomas, *On the Truth of the Catholic Faith*, book 2, chap. 89, sec. 9–10.

25. Ibid., 11: "Anima igitur vegetabilis, quae primo inest, cum embryo vivit vita plantae, corrumpitur, et succedit anima perfectior, quae est nutritiva et sensitiva simul, et tunc embryo vivit vita animalis; hac autem corrupta, succedit anima rationalis ab extrinseco immissa, licet praecedentes fuerint virtute seminis."

26. Thomas, *On the Power of God*, question 3, articles 9–10.

27. Cf., Robert Henle, S.J., *Saint Thomas and Platonism* (The Hague: Nijhoff, 1956).

28. See the very end of Thoreau's chapter "Higher Laws" in *Walden* (New York: New American Library, 1980).

29. See Richard McCormick, "Rules for Abortion Debate," in *Abortion: A Reader*, ed. Lloyd Steffen (Cleveland: Pilgrim Press, 1996).

30. See Beverly Whelton, "Human Nature, Substantial Change, and Modern Science: Rethinking When a New Human Life Begins," *American Catholic Philosophical Quarterly* 72 (1998).

Chapter 2: The Influence of the Seventeenth Century

1. Once again, see Augustine's *De Nuptiis et Concupiscentia*, I, 17. For an English translation, see *On Marriage and Concupiscence*.

2. In addition to Messenger, de Dorlodot, and Donceel see the following by James Rachels, *The Elements of Moral Philosophy* (New York: McGraw-Hill, 1993), pp. 55–61; *The End of Life: Euthanasia and Morality* (Oxford: Oxford University Press, 1986), pp. 68–72; and *Created from Animals: The Moral Implications of Darwinism* (Oxford: Oxford University Press, 1990), pp. 91–98.

3. The details regarding seventeenth-century biology can be explored in several sources. Among these is Richard Westfall, *The Construction of Modern Science: Mechanisms and Mechanics* (Cambridge: Cambridge University Press, 1971), esp. pp. 97–104. The Hartsoeker diagram can be found on p. 103. Also see Erik Nordenskiold, *The History of Biology*, trans. L. B. Eyre (New York, 1935); and Howard Adelmann, *Marcello Malpighi and the Evolution of Embryology*, 5 vols. (Ithaca: Cornell University Press, 1966).

4. Westfall, *Construction of Modern Science*, pp. 84, 99–100, 113. Also see E. C. Messenger, "A Short History of Embryology," in *Theology and Evolution*, ed. E. C. Messenger (London: Sands, 1949), pp. 238, 241.

5. Westfall, *Construction of Modern Science*, pp. 86–94, 96–100, 103–4, 115. Also see Messenger, *Theology and Evolution*, pp. 238, 241.

6. Concerning the history detailed in the above two paragraphs see several articles by E. C. Messenger and Henry de Dorlodot in *Theology and Evolution*, ed. E. C. Messenger, pp. 219–332. On de Dorlodot's claim that the "facts" regarding immediate hominization were "absolutely established" by the mid-eighteenth century see p. 273. And on Messenger's belief that delayed hominization is the *only* theory compatible with contemporary science see p. 220. Also see Thomas Shannon and Allan Wolter, O.F.M., "Reflections on the Moral Status of the Pre-Embryo," *Theological Studies* 51 (1990).

7. In *Science and the Modern World* (New York: Macmillan, 1925) Alfred North Whitehead offers the classic arguments in favor of the view that the seventeenth century is the most decisive one in reifying certain metaphysical mistakes that have had a deleterious effect on ethics, with dualism being one of the most prominent of these mistakes.

8. Shannon and Wolter, "Reflections on the Moral Status of the Pre-Embryo," pp. 603–26.

9. Lisa Sowle Cahill, "The Embryo and the Fetus: New Moral Contexts," *Theological Studies* 54 (1993).

10. Once again, see Messenger's *Theology and Evolution*. Pages 219–326 of this book are essential reading for those who are interested in the topic of the present chapter. Throughout the book, as we have mentioned, we have used "fetus" widely to refer to all the stages of embryonic development; in treating Shannon and Wolter, however, we have distinguished between the pre-embryo or zygote, on the one hand, and

the embryo, on the other. It should also be noted that de Dorlodot, along with others, misleadingly talks of immediate animation rather than immediate hominization; immediate animation is not bothersome, as we see things.

11. Shannon and Wolter, "Reflections on the Moral Status of the Pre-Embryo," pp. 604–6.

12. Ibid., pp. 607–14.

13. See the article by Henry de Dorlodot, "A Vindication of the Mediate Animation Theory," in *Theology and Evolution*, ed. Messenger.

14. Shannon and Wolter, "Reflections on the Moral Status of the Pre-Embryo," pp. 615–19.

15. Ibid., p. 620.

16. Ibid., pp. 622–24.

17. Ibid., p. 605.

18. Ibid., p. 603.

19. De Dorlodot, "Vindication of the Mediate Animation Theory," p. 219.

20. See F. E. Cangiamila, *Embryologia sacra* (Ipris, 1775), pp. 47, 61.

21. See E. Müller, *Das Konzil von Vienne* (Münster, 1934). The acts of this council have been almost entirely lost.

22. See Donceel, "Immediate Animation and Delayed Hominization," pp. 89–90. Also see Donceel's other articles: "Liberal Catholic's View" and "Abortion: Mediate v. Immediate Animation."

23. Regarding Gassendi and Fienus see Pierre Gassendi, *Opera Omnia*, vol. 2: *De Generatione Animalium* (Stuttgart: Frommann Verlag, 1964); G. S. Brett, *The Philosophy of Gassendi* (London: Macmillan, 1908); and Thomas Fienus, *De formatione foetus liber, in quo ostenditur animam rationalem infundi tertia die* (Antwerp, 1620).

24. James Reichmann, S.J., *Philosophy of the Human Person* (Chicago: Loyola University Press, 1985), pp. 250–57.

25. Once again, see Donceel's "Immediate Animation and Delayed Hominization."

26. See Messenger's *Theology and Evolution*, pp. 237–38, 271–72. Also see Shannon and Wolter, "Reflections on the Moral Status of the Pre-Embryo," pp. 605, 615.

27. See Charles Curran, "Abortion: Its Moral Aspects," in *Abortion: A Reader*, ed. Lloyd Steffen (Cleveland: Pilgrim Press, 1996). By way of contrast, an author who has a view similar to our own and to Donceel's is Wilfried Ruff; see "Das embryoale Werden des Individuums," *Stimmen der Zeit* 181 (1968); "Das embryoale Werden des Menschen," *Stimmen der Zeit* 181 (1968); and "Individualität und Personalität in embryoanalen Werden," *Theologie et Philosophie* 45 (1970).

28. See Clara Pinto Correia, *The Ovary of Eve* (Chicago: University of Chicago Press, 1997), esp. p. 165.

Chapter 3: The Importance of Temporal Asymmetry

1. Morowitz and Trefil, *Facts of Life*, pp. 17, 49.

2. Ibid., pp. 50–52.

3. Ibid., pp. 79–80, 84, 113, 116, 157. Also see Bernard Häring, *Medical Ethics* (Slough, U.K.: St. Paul Publications, 1972); and Pierre Teilhard de Chardin, *The Phenomenon of Man* (New York: Harper and Row, 1959).

4. Morowitz and Trefil, *Facts of Life*, pp. 117, 122, 158.

5. Ibid., pp. 127, 146. It is worth noting that one of the authors of the Morowitz and Trefil book is predisposed to defend a "pro-life" stance.

6. Paul Badham, "Christian Belief and the Ethics of In-Vitro Fertilization and Abortion," *Bioethics News* 6 (1987). Cf. Stephen Heaney, "Aquinas and the Presence of the Human Rational Soul in the Early Embryo," *Thomist* 56 (1992).

7. Charles Hartshorne, *Wisdom as Moderation* (Albany: State University of New York Press, 1987), pp. 18–19.

8. Charles Hartshorne, *Omnipotence and Other Theological Mistakes* (Albany: State University of New York Press, 1984), pp. 104–5.

9. Ibid.

10. Charles Hartshorne, *Creative Synthesis and Philosophic Method* (LaSalle, Ill.: Open Court, 1970), p. 8.

11. Ibid., p. 20.

12. Ibid., p. 23.

13. Ibid., p. 44. Also see Hartshorne's *The Logic of Perfection* (LaSalle, Ill.: Open Court, 1962), p. 17.

14. Hartshorne, *Creative Synthesis and Philosophic Method*, p. 174.

15. Ibid., p. 180.

16. Ibid., p. 183.

17. Ibid., p. 184.

18. Hartshorne, *Logic of Perfection*, p. 120.

19. Hartshorne, *Creative Synthesis and Philosophic Method*, p. 185.

20. Charles Hartshorne, *Creativity in American Philosophy* (Albany: State University of New York Press, 1984), p. 160.

21. Ibid., p. 168.

22. Ibid., pp. 86–87.

23. Hartshorne, *Omnipotence and Other Theological Mistakes*, p. 105.

24. Ibid., pp. 107–8.

25. Hartshorne, *Creative Synthesis and Philosophic Method*, p. 83.

26. Ibid., p. 96.

27. Ibid., pp. 147, 213.

28. Ibid., p. 216.

29. Ibid.

30. Hartshorne, *Logic of Perfection*, p. 174.

31. Hartshorne, *Creativity in American Philosophy*, p. 156.

32. See Daniel Dombrowski, *Hartshorne and the Metaphysics of Animal Rights* (Albany: State University of New York Press, 1988).

33. Hartshorne, *Wisdom as Moderation*, pp. 4–5.

34. Ibid., pp. 59–60. Also see Francis Wade, S.J., "Potentiality in the Abortion Discussion," *Review of Metaphysics* 29 (1975). Cf. a defense of delayed hominization by William Wallace, O.P., "Nature and Human Nature as the Norm in Medical Ethics," in *Catholic Perspectives on Medical Morals*, ed. Edmund Pellegrino (Dordrecht: Kluwer, 1989). Karl Rahner was also favorably disposed toward delayed hominization; see Ranke-Heinemann, *Eunuchs for the Kingdom of Heaven*, p. 306.

35. Hartshorne, *Wisdom as Moderation*, p. 125.

36. Ibid., p. 126.

37. Randolph Feezell, "Potentiality, Death, and Abortion," *Southern Journal of Philosophy* 25 (1987), 47.

38. Ibid., p. 46.

39. Ibid., pp. 44–45.

40. Ibid., p. 45.

41. Ibid., p. 43. Don Marquis would disagree with us. Marquis argues that the primary wrong-making feature of a killing, including the killing of a fetus by means of induced abortion, is the loss to the victim of the value of its future—specifically, a loss of "the experiences, activities, projects, and enjoyments" that would otherwise have constituted its future. Hence, "morally permissible abortions will be rare indeed unless, perhaps, they occur so early in pregnancy that a fetus is *not yet definitely an individual*" (our emphasis). For Marquis the "individual" need not be a person for abortion to be wrong—the category of personhood is not central to his analysis—but it need not be sentient either. See Don Marquis, "Why Abortion Is Immoral," *Journal of Philosophy* 86 (1989).

42. See Daniel Dombrowski, *The Philosophy of Vegetarianism* (Amherst: University of Massachusetts Press, 1984); and *Babies and Beasts: The Argument from Marginal Cases* (Urbana: University of Illinois Press, 1997).

43. See Joel Feinberg and Barbara Baum Levenbook, "Abortion," esp. pp. 206–9, 212. Below regarding L. W. Sumner see his "Abortion: A Moderate View," in *Contemporary Moral Problems*, ed. James White (Minneapolis: West Publishing, 1997).

44. Hartshorne, *Omnipotence and Other Theological Mistakes*, pp. 99–101.

45. Hartshorne, *Wisdom as Moderation*, p. 33.

46. Hartshorne, *Omnipotence and Other Theological Mistakes*, p. 55.

47. Michael Tooley, "Abortion and Infanticide," *Philosophy and Public Affairs* 2 (1972).

48. Hartshorne, *Omnipotence and Other Theological Mistakes*, p. 101.

49. Ibid., pp. 102–3.

50. Ibid., p. 103.

51. Ibid., p. 112, also pp. 116–17.

52. Ibid., p. 13. Also see Hartshorne, *Wisdom as Moderation*, p. 49; and "Foundations for a Humane Ethics," in *On the Fifth Day*, ed. R. K. Morris (Washington, D.C.: Acropolis Press, 1978).

53. Hartshorne, *Creativity in American Philosophy*, p. 87.

54. See James Nelson, "Protestant Attitudes toward Abortion," in *Abortion: A Reader*, ed. Lloyd Steffen (Cleveland: Pilgrim Press, 1996). Protestants, like Catholics, are divided on the issue of abortion. Contrast Karl Barth, "The Protection of Life," with James Gustafson, "A Protestant Ethical Approach." Both of these articles are in *On Moral Medicine*, ed. Stephen E. Lammers and Allen Verhey. Gustafson's approach is much closer to our stance than is Barth's. One of the problems with Barth's approach is that he seems to think that there is a brain and a central nervous system in the fetus "from the very first," which is bad biology. Also see Fazlur Rahman, "Birth and Abortion in Islam," and Isaac Klein, "Abortion: A Jewish View"; both essays are in *Abortion: A Reader*, ed. Lloyd Steffen (Cleveland: Pilgrim Press, 1996). Also, see Pope Paul VI, "Pourquoi l'eglise ne peut accepter l'avortement," *Documentation Catholique* 70 (1973). The quote from Charles Hartshorne is from "Concerning Abortion: An Attempt at a Rational View," in Steffen, p. 59.

55. See a very good article by Peter Wenz, "The Law and Fetal Personhood: Religious and Secular Determinations," in *Abortion: A Reader*, ed. Lloyd Steffen (Cleveland: Pilgrim Press, 1996). Also see another fine collection of essays, edited by Patricia Jung and Thomas Shannon, *Abortion and Catholicism: The American Debate* (New York: Crossroad, 1988), especially an excellent article on probabilism by Carol Tauer, "The Tradition of Probabilism and the Moral Status of the Early Embryo."

56. It should now be clear that those who place hominization at around fourteen days, when physical individuation has taken place, are from our point of view barely distinguishable from those who defend immediate hominization. See Charles Curran's article in the Steffen anthology.

Chapter 4: A Defensible Sexual Ethic

1. See Michael Lawler, *Secular Marriage, Christian Sacrament* (Mystic, Conn.: Twenty-Third Publications, 1985).

2. See Peter Brown, *Augustine of Hippo: A Biography* (Berkeley: University of California Press, 1967); and *The Body and Society: Men, Women, and Sexual Renunciation in Early Christianity* (Boulder: University of Colorado Press, 1990).

3. Tristram Coffin, "Earth, the Crowded Planet," and Jacqueline Kasun, "The Unjust War against Population," both in *Environmental Ethics*, ed. Louis Pojman (Boston: Jones and Bartlett, 1994).

4. Thomas Nagel, "Sexual Perversion," in *Mortal Questions* (Cambridge: Cambridge University Press, 1991).

5. Also see an excellent article by Bonnie Steinbock, "Adultery," in *Values and Public Policy*, ed. Claudia Mills (New York: Harcourt, Brace, and Jovanovich, 1992).

6. Roger Scruton, *Sexual Desire* (Boston: Free Press, 1986). Also anthologized in part in *Applying Ethics*, ed. Jeffrey Olen and Vincent Barry (Los Angeles: Wadsworth, 1996).

7. See Scruton's essay in *Applying Ethics*, p. 88.

8. See Jane Hurst, *The History of Abortion in the Catholic Church* (Washington, D.C.: Catholics for a Free Choice, 1989).

9. Ibid.

10. Ibid. Also see Harrison, "Theology and Morality of Procreative Choice." Once again, for some instructive feminist remarks on abortion consult Ranke-Heinemann, *Eunuchs for the Kingdom of Heaven*, pp. 298–311, as well as another article by Harrison, "A Feminist-Liberation View of Abortion," in *On Moral Medicine*, ed. Stephen E. Lammers and Allen Verhey, 2d ed. (Grand Rapids, Mich.: Eerdmans, 1998).

11. See Hurst, *History of Abortion*.

12. See Nicholson's carefully argued *Abortion and the Roman Catholic Church*.

13. See Thomas's *On the Truth of the Catholic Faith* (*Summa Contra Gentiles*), book 3, chap. 122; also see *On Evil* (Notre Dame: University of Notre Dame Press, 1995), question 15, article 2.

Chapter 5: Catholicism and Liberalism

1. Stephen R. L. Clark, *Civil Peace and Sacred Order* (Oxford: Clarendon Press, 1989), p. 59.

2. Stephen R. L. Clark, *A Parliament of Souls* (Oxford: Clarendon Press, 1990), p. 1.

3. Ibid., p. 25.

4. Stephen R. L. Clark, *God's World and the Great Awakening* (Oxford: Clarendon Press, 1991), p. 37.

5. Alasdair MacIntyre, *After Virtue* (Notre Dame: University of Notre Dame Press, 1981), pp. 232–33.

6. Rawls's two principles of justice are as follows: (a) Each person has an equal claim to a fully adequate scheme of basic rights and liberties, which scheme is compatible with the same scheme for all; and in this scheme the equal political liberties, and only those liberties, are to be

guaranteed their fair value. And (b), social and economic inequalities are to satisfy two conditions: first, they are to be attached to positions and offices open to all under conditions of fair equality of opportunity; and second, they are to be to the greatest benefit of the least advantaged members of society. The second principle (b) is known as the difference principle.

7. John Rawls, "Justice as Fairness," *Philosophical Review* 67 (1958), 174.

8. It does not seem that this was the personal view of Glaucon; rather, he was playing the devil's advocate for what most people think. See *Republic* 358A, 361E.

9. Whether Plato mischaracterizes the sophist's position is a matter of debate. Rawls thinks that he does, relying on Karl Popper, *The Open Society and Its Enemies*, vol. 1: *The Spell of Plato*, rev. ed. (Princeton: Princeton University Press, 1950), pp. 112–18. Cf. Ronald Levinson, *In Defense of Plato* (New York: Russell and Russell, 1953), pp. 58–61, 154–56.

10. Rawls, "Justice as Fairness," p. 175.

11. John Rawls, *A Theory of Justice* (Cambridge: Harvard University Press, 1971), p. 13.

12. Ibid., p. 142.

13. Ibid., pp. 142–43.

14. Ibid., p. 189.

15. Ibid., p. 281.

16. Ibid., p. 521. Rawls cites *Republic* 369 and 372.

17. Ibid., p. 560.

18. Ibid., pp. 395–99.

19. Ibid., p. 454. See *Republic* 414–15. Also see Daniel Dombrowski's perhaps overly generous treatments of Plato: "*Republic* 414B–C: Noble *Lies, Noble* Lies, or *Noble* 'Lies'?" *Classical Bulletin* 58 (1981), 4–6; and "*Republic* 414B–C, Again," *Liverpool Classical Monthly* 10, no. 3 (1985), 36–38; finally, see "Plato's 'Noble' Lie," *History of Political Thought* 18 (1997).

20. MacIntyre, *After Virtue*, pp. 176–78.

21. Rawls, *Theory of Justice*, pp. 325–32.

22. John Rawls, *Political Liberalism* (New York: Columbia University Press, 1993), pp. 104–5.

23. Ibid., pp. 106–7.

24. Ibid., pp. 147–48.

25. Ibid., pp. 148–49.

26. Ibid., pp. 159–61.

27. Ibid., pp. 163–64, 168.

28. Ibid., pp. 169–71, 208, 218, 249.

29. Rawls, *Theory of Justice*, p. 587.

30. See Daniel Dombrowski, "On Why Patriotism Is Not a Virtue," *International Journal of Applied Philosophy* 7 (1992); and "Thomas Nagel as a Process Philosopher," *American Journal of Theology and Philosophy* 15 (1994). Also see Thomas Nagel, *Mortal Questions*, and *The View from Nowhere* (Oxford: Oxford University Press, 1986).

31. Rawls, *Political Liberalism*, pp. 240–41.

32. Ibid., p. 244.

33. Stanley Hauerwas, "Abortion: Why the Arguments Fail," in *Abortion: A Reader*, ed. Lloyd Steffen (Cleveland: Pilgrim Press, 1996), pp. 295–99.

34. Ibid., pp. 300–313. Also see Daniel Maguire, "Catholic Options in the Abortion Debate," *Conscience: A Newsjournal of Prochoice Catholic Opinion* 17 (Summer, 1996).

35. Lisa Sowle Cahill, "Abortion, Autonomy, and Community," in *Abortion: A Reader*, ed. Lloyd Steffen (Cleveland: Pilgrim Press, 1996), p. 365.

36. Ibid., pp. 368–69.

37. See St. Thomas Aquinas, *Summa Theologiae*, 2a2ae, question 11, article 3: "Whether Heretics Ought to Be Tolerated?"

38. See R. Bruce Douglass, "Introduction" and "Liberalism after the Good Times," in *Catholicism and Liberalism*, ed. R. Bruce Douglass and David Hollenbach, S.J. (Cambridge: Cambridge University Press, 1996). Also in this volume see David Hollenbach, S.J., "A Communitarian Reconstruction of Human Rights" and "Afterword"; and Louis Dupré, "The Common Good and the Open Society."

39. Ronald Dworkin, "What Is Sacred?" in *Abortion: A Reader*, ed. Lloyd Steffen (Cleveland: Pilgrim Press, 1996), p. 66.

40. See Philip Quinn, "Political Liberalisms and Their Exclusions of the Religious," *Proceedings and Addresses of the American Philosophical Association* 69, no. 2 (1995); Kent Greenawalt, *Religious Convictions and Political Choice* (New York: Oxford University Press, 1988); Michael Perry, *Love and Power: The Role of Religion and Morality in American Politics* (New York: Oxford University Press, 1991); Robert M. Adams, "Religious Ethics in a Pluralistic Society," in *Prospects for a Common Morality*, ed. Gene Outka and John Reeder (Princeton: Princeton University Press, 1993); and Jeremy Waldron, "Religious Contributions in Public Deliberation," *San Diego Law Review* 30 (1993).

41. The *Roe v. Wade* decision is anthologized in many places. An abridged version can be found in *Moral Problems*, ed. James Rachels (New York: Harper Collins, 1979). Also see Morowitz and Trefil, *Facts of Life*, p. 160, on scientists "hitting the wall" regarding the possibility of pushing back further the time when viability commences. Finally, see

Mark Graber's defense of abortion rights, even among those who have reservations about the morality of abortion: *Rethinking Abortion* (Princeton: Princeton University Press, 1996).

42. Bill Clinton, "Clinton Response," *National Right to Life News* 23 (July 2, 1996). Late-term abortions in order to preserve the health of the mother, mentioned in Blackmun's opinion, are crucial in order to understand Clinton's quite intelligible and nuanced position.

Afterword

1. See John Noonan, "The Experience of Pain by the Unborn," in *New Perspectives on Human Abortion*, ed. Thomas Hilgers (Frederick, Md.: University Publications of America, 1981), p. 205. Cf. Mary Gore Forrester, *Persons, Animals, and Fetuses* (Boston: Kluwer Academic Publishers, 1996).

2. St. Thomas Aquinas, *Summa Theologiae*, 1a2ae, question 35, article 7.

3. See Daniel Dombrowski, "Vegetarianism and the Argument from Marginal Cases in Porphyry," *Journal of the History of Ideas* 45 (1984); also see *Philosophy of Vegetarianism, Hartshorne and the Metaphysics of Animal Rights*, and *Babies and Beasts*.

4. See Daniel Dombrowski, "Must a Pacifist Also Be Opposed to Euthanasia?" *Journal of Value Inquiry* 30 (1996); also see *Christian Pacifism*. Cf. Sidney Callahan, "Abortion and the Sexual Agenda: A Case for Pro-Life Feminism," in *On Moral Medicine*, ed. Stephen E. Lammers and Allen Verhey, 2d ed. (Grand Rapids, Mich.: Eerdmans, 1998), pp. 626–27. Callahan realizes that if the criterion for moral patiency status is made too high (e.g., rationality) then marginal humans would be excluded, but she is willing to lower the criterion all the way to life without indicating the implications such a lowering would have regarding our eating of plants, our excising of cancerous tumors, etc.

5. See Mark Johnson, "Reflections on Some Recent Catholic Claims for Delayed Hominization," *Theological Studies* 56 (1995).

6. See Jean Porter, "Individuality, Personal Identity, and the Moral Status of the Preembryo: A Response to Mark Johnson," *Theological Studies* 56 (1995); James Diamond, "Abortion, Animation, and Biological Hominization," *Theological Studies* 36 (1975); Thomas Bole, "Zygotes, Souls, Substances, and Persons," *Journal of Medicine and Philosophy* 15 (1990). Also see two related studies: Norman Ford, S.D.B., *When Did I Begin?* (Cambridge: Cambridge University Press, 1988); and Carlos Bedate and Robert Cefalo, "The Zygote: To Be or Not Be a Person," *Journal of Medicine and Philosophy* 14 (1989).

7. *Seattle Times*, July 29, 1996, p. A3.

Bibliography

Adams, Robert M. "Religious Ethics in a Pluralistic Society." In *Prospects for a Common Morality*, edited by Gene Outka and John Reeder. Princeton: Princeton University Press, 1993.

Adelmann, Howard. *Marcello Malpighi and the Evolution of Embryology*. 5 vols. Ithaca: Cornell University Press, 1966.

Anand, K. J. S., and P. R. Hickey. "Pain and Its Effects in the Human Neonate and Fetus." *New England Journal of Medicine* 317, no. 21 (Nov. 19, 1987).

Aristotle. *Generation of Animals*. Loeb edition. Cambridge: Harvard University Press, 1953.

———. *History of Animals*. In *The Complete Works of Aristotle*. Princeton: Princeton University Press, 1984.

———. *Politics*. In *The Complete Works of Aristotle*. Princeton: Princeton University Press, 1984.

Augustine, St. *Against Julian*. The Fathers of the Church, vol. 35. New York: Fathers of the Church, 1957. Also *Contra Julianum Pelagianum* in *Contra Pelagianos*, vol. 10 of *Opera Omnia*, edited by J.-P. Migne. Paris, 1861–65.

———. *The City of God*. Edited by Philip Schaff. Nicene and Post-Nicene Fathers, vol. 2. Grand Rapids, Mich.: Eerdmans, 1956. Also *De Civitate Dei*, vol. 7 of *Opera Omnia*, edited by J.-P. Migne. Paris, 1861–65.

———. *Enchiridion*. Edited by Philip Schaff. Nicene and Post-Nicene Fathers, vol. 3. Grand Rapids, Mich.: Eerdmans, 1956. Also *Enchiridion, Sive de Fide, Spe et Charitate* in *Opera Moralia*, vol. 6 of *Opera Omnia*, edited by J.-P. Migne. Paris, 1861–65.

———. *On Marriage and Concupiscence.* Edited by Philip Schaff. Nicene and Post-Nicene Fathers, vol. 5. Grand Rapids, Mich.: Eerdmans, 1956. Also *De Nuptiis et Concupiscentia* in *Contra Pelagianos,* vol. 10 of *Opera Omnia,* edited by J.-P. Migne. Paris, 1861–65.

———. *Quaestionum S. Augustini in Heptateuchum.* Vol. 34 of Patrologiae Cursus Completus, Series Latina, edited by J.-P. Migne. Paris, 1845.

Badham, Paul. "Christian Belief and the Ethics of In-Vitro Fertilization and Abortion." *Bioethics News* 6 (1987).

Barth, Karl. "The Protection of Life." In *On Moral Medicine,* edited by Stephen E. Lammers and Allen Verhey. Grand Rapids, Mich.: Eerdmans, 1987.

Bedate, Carlos, and Robert Cefalo. "The Zygote: To Be or Not Be a Person." *Journal of Medicine and Philosophy* 14 (1989).

Bole, Thomas. "Zygotes, Souls, Substances, and Persons." *Journal of Medicine and Philosophy* 15 (1990).

Brett, G. S. *The Philosophy of Gassendi.* London: Macmillan, 1908.

Brown, Peter. *Augustine of Hippo: A Biography.* Berkeley: University of California Press, 1967.

———. *The Body and Society: Men, Women, and Sexual Renunciation in Early Christianity.* Boulder: University of Colorado Press, 1990.

Cahill, Lisa Sowle. "Abortion, Autonomy, and Community." In *Abortion: A Reader,* edited by Lloyd Steffen. Cleveland: Pilgrim Press, 1996. Also in *Abortion: Understanding Differences,* edited by Daniel Callahan and Sidney Callahan. New York: Plenum Press, 1984.

———. "The Embryo and the Fetus: New Moral Contexts." *Theological Studies* 54 (1993).

Callahan, Daniel. "The Roman Catholic Position." In *Abortion: A Reader,* edited by Lloyd Steffen. Cleveland: Pilgrim Press, 1996. Also in Daniel Callahan, *Abortion: Law, Choice, and Morality.* New York: Simon and Schuster, 1970.

Callahan, Sidney. "Abortion and the Sexual Agenda: A Case for Pro-Life Feminism." In *On Moral Medicine,* edited by Stephen E. Lammers and Allen Verhey. 2d ed. Grand Rapids, Mich.: Eerdmans, 1998.

Cangiamila, F. E. *Embryologia sacra.* Ipris, 1775.

Canon Law: Letter and Spirit. Collegeville, Minn.: Liturgical Press, 1995.

Carlson, Bruce. *Patten's Foundations of Embryology.* 6th ed. New York: McGraw-Hill, 1996.

Carrick, Paul. *Medical Ethics in Antiquity.* Boston: D. Reidel, 1985.

Clark, Stephen R. L. *Civil Peace and Sacred Order.* Oxford: Clarendon Press, 1989.

———. *God's World and the Great Awakening.* Oxford: Clarendon Press, 1991.

———. *A Parliament of Souls.* Oxford: Clarendon Press, 1990.

Clinton, Bill. "Clinton Response." *National Right to Life News* 23 (July 2, 1996).

Coffin, Tristram. "Earth, the Crowded Planet." In *Environmental Ethics*, edited by Louis Pojman. Boston: Jones and Bartlett, 1994.

Connery, John, S.J. *Abortion: The Development of the Roman Catholic Perspective.* Chicago: Loyola University Press, 1977.

Correia, Clara Pinto. *The Ovary of Eve.* Chicago: University of Chicago Press, 1997.

Curran, Charles. "Abortion: Its Moral Aspects." In *Abortion: A Reader*, edited by Lloyd Steffen. Cleveland: Pilgrim Press, 1996. Also in *Jurist* 33 (1973).

de Dorlodot, H. "A Vindication of the Mediate Animation Theory." In *Theology and Evolution*, edited by E. C. Messenger. London: Sands, 1949.

Diamond, James. "Abortion, Animation, and Biological Hominization." *Theological Studies* 36 (1975).

Dombrowski, Daniel. *Babies and Beasts: The Argument from Marginal Cases.* Urbana: University of Illinois Press, 1997.

———. *Christian Pacifism.* Philadelphia: Temple University Press, 1991.

———. "The Confessions of Augustine and DeQuincey." *Augustinian Studies* 18 (1987).

———. *Hartshorne and the Metaphysics of Animal Rights.* Albany: State University of New York Press, 1988.

———. "Must a Pacifist Also Be Opposed to Euthanasia?" *Journal of Value Inquiry* 30 (1996).

———. "On Why Patriotism Is Not a Virtue." *International Journal of Applied Philosophy* 7 (1992).

———. *The Philosophy of Vegetarianism.* Amherst: University of Massachusetts Press, 1984.

———. "Plato's 'Noble' Lie." *History of Political Thought* 18 (1997).

———. "*Republic* 414B–C: Noble *Lies*, *Noble* Lies, or *Noble* 'Lies'?" *Classical Bulletin* 58 (1981).

———. "*Republic* 414B–C, Again." *Liverpool Classical Monthly* 10, no. 3 (1985).

———. "Starnes on Augustine's Theory of Infancy: A Piagetian Critique." *Augustinian Studies* 11 (1980).

———. "Thomas Nagel as a Process Philosopher." *American Journal of Theology and Philosophy* 15 (1994).

———. "Vegetarianism and the Argument from Marginal Cases in Porphyry." *Journal of the History of Ideas* 45 (1984).

———. "The Virtue of Boldness." *Spirituality Today* 37 (1985).

Donceel, Joseph. "Abortion: Mediate v. Immediate Animation." *Continuum* 5 (1967).

————. "Immediate Animation and Delayed Hominization." *Theological Studies* 31 (1970).

————. "A Liberal Catholic's View." In *Abortion in a Changing World*, edited by Robert Hall. New York: Columbia University Press, 1970.

Douglass, R. Bruce. "Liberalism after the Good Times." In *Catholicism and Liberalism*, edited by R. Bruce Douglass and David Hollenbach, S.J. Cambridge: Cambridge University Press, 1996.

Dupré, Louis. "The Common Good and the Open Society." In *Catholicism and Liberalism*, edited by R. Bruce Douglass and David Hollenbach, S.J. Cambridge: Cambridge University Press, 1996.

Dworkin, Ronald. "What Is Sacred?" In *Abortion: A Reader*, edited by Lloyd Steffen. Cleveland: Pilgrim Press, 1996. Also in *Life's Dominion*. New York: Random House, 1993.

Farley, Margaret. "Liberation, Abortion, and Responsibility." In *On Moral Medicine*, edited by Stephen E. Lammers and Allen Verhey. Grand Rapids, Mich.: Eerdmans, 1987.

Feezell, Randolph. "Potentiality, Death, and Abortion." *Southern Journal of Philosophy* 25 (1987).

Feinberg, Joel, and Barbara Baum Levenbook. "Abortion." In *Matters of Life and Death*, edited by Tom Regan. New York: McGraw-Hill, 1993.

Fienus, Thomas. *De formatione foetus liber, in quo ostenditur animam rationalem infundi tertia die*. Antwerp, 1620.

Ford, Norman, S.D.B. *When Did I Begin?* Cambridge: Cambridge University Press, 1988.

Forrester, Mary Gore. *Persons, Animals, and Fetuses*. Boston: Kluwer Academic Publishers, 1996.

Gardner, Charles. "Is an Embryo a Person?" *Nation*, Nov. 13, 1989.

Gassendi, Pierre. *Opera Omnia*, vol. 2: *De Generatione Animalium*. Stuttgart: Frommann Verlag, 1964.

Gorman, Michael. *Abortion and the Early Church*. New York: Paulist Press, 1982.

Graber, Mark. *Rethinking Abortion*. Princeton: Princeton University Press, 1996.

Greenawalt, Kent. *Religious Convictions and Political Choice*. New York: Oxford University Press, 1988.

Grobstein, Clifford. *Science and the Unborn*. New York: Basic Books, 1988.

Gustafson, James. "A Protestant Ethical Approach." In *On Moral Medicine*, edited by Stephen E. Lammers and Allen Verhey. Grand Rapids, Mich.: Eerdmans, 1987.

Häring, Bernard. *Medical Ethics*. Slough, U.K.: St. Paul Publications, 1972.

Harrison, Beverly Wildung. "A Feminist-Liberation View of Abortion."

In *On Moral Medicine,* edited by Stephen E. Lammers and Allen Verhey. 2d ed. Grand Rapids, Mich.: Eerdmans, 1998.

————. "Theology and Morality of Procreative Choice." In *Abortion: A Reader,* edited by Lloyd Steffen. Cleveland: Pilgrim Press, 1996. Also in *Making the Connections.* Boston: Beacon Press, 1985. Also in *On Moral Medicine,* edited by Stephen E. Lammers and Allen Verhey. Grand Rapids, Mich.: Eerdmans, 1987.

Hartshorne, Charles. "Concerning Abortion: An Attempt at a Rational View." In *Abortion: A Reader,* edited by Lloyd Steffen. Cleveland: Pilgrim Press, 1996. Also in *Christian Century,* Jan. 21, 1981.

————. *Creative Synthesis and Philosophic Method.* LaSalle, Ill.: Open Court, 1970.

————. *Creativity in American Philosophy.* Albany: State University of New York Press, 1984.

————. "Foundations for a Humane Ethics." In *On the Fifth Day,* edited by R. K. Morris. Washington, D.C.: Acropolis Press, 1978.

————. *The Logic of Perfection.* LaSalle, Ill.: Open Court, 1962.

————. *Omnipotence and Other Theological Mistakes.* Albany: State University of New York Press, 1984.

————. *Wisdom as Moderation.* Albany: State University of New York Press, 1987.

Hartsoeker, Nicolas. *Essai de dioptrique.* Paris: Jean Anisson, 1694.

Hauerwas, Stanley. "Abortion: Why the Arguments Fail." In *Abortion: A Reader,* edited by Lloyd Steffen. Cleveland: Pilgrim Press, 1996. Also in *A Community of Character: Towards a Constructive Christian Social Ethic.* Notre Dame: University of Notre Dame Press, 1981.

Heaney, Stephen. "Aquinas and the Presence of the Human Rational Soul in the Early Embryo." *Thomist* 56 (1992).

Henle, Robert, S.J. *Saint Thomas and Platonism.* The Hague: Nijhoff, 1956.

Hollenbach, David, S.J. "A Communitarian Reconstruction of Human Rights." In *Catholicism and Liberalism,* edited by R. Bruce Douglass and David Hollenbach, S.J. Cambridge: Cambridge University Press, 1996.

Hurst, Jane. *The History of Abortion in the Catholic Church.* Washington, D.C.: Catholics for a Free Choice, 1989.

Johnson, Mark. "Reflections on Some Recent Catholic Claims for Delayed Hominization." *Theological Studies* 56 (1995).

Jung, Patricia, and Thomas Shannon, eds. *Abortion and Catholicism: The American Debate.* New York: Crossroad, 1988.

Kamm, F. M. *Creation and Abortion.* New York: Oxford University Press, 1992.

Kasun, Jacqueline. "The Unjust War against Population." In *Environ-*

mental Ethics, edited by Louis Pojman. Boston: Jones and Bartlett, 1994.

Kircher, Athanasius. *Athanasii Kircheri & Soc. Jesu mundus subterra-neus, in XII libros digestus.* Amsterdam: Joannem Janssonium a Waesberge & fillios, 1678.

Klein, Isaac. "Abortion: A Jewish View." In *Abortion: A Reader,* edited by Lloyd Steffen. Cleveland: Pilgrim Press, 1996. Also in *Dublin Review* 514 (1967–68).

Lawler, Michael. *Secular Marriage, Christian Sacrament.* Mystic, Conn.: Twenty-Third Publications, 1985.

Levinson, Ronald. *In Defense of Plato.* New York: Russell and Russell, 1953.

MacIntyre, Alasdair. *After Virtue.* Notre Dame: University of Notre Dame Press, 1981.

Maguire, Daniel. "Abortion: A Question of Catholic Honesty." In *Abortion: A Reader,* edited by Lloyd Steffen. Cleveland: Pilgrim Press, 1996. Also in *Christian Century,* Sept. 14–21, 1983.

———. "Catholic Options in the Abortion Debate." *Conscience: A Newsjournal of Prochoice Catholic Opinion* 17 (Summer, 1996).

Maguire, Daniel, and James Burtchaell, C.S.C. "The Catholic Legacy and Abortion: A Debate." In *On Moral Medicine,* edited by Stephen E. Lammers and Allen Verhey. 2d ed. Grand Rapids, Mich.: Eerdmans, 1998.

Maguire, Marjorie Reiley. "Personhood, Covenant, and Abortion." In *Abortion: A Reader,* edited by Lloyd Steffen. Cleveland: Pilgrim Press, 1996.

Marquis, Don. "Why Abortion Is Immoral." *Journal of Philosophy* 86 (1989).

McCartney, James. "Some Roman Catholic Concepts of Person and Their Implications for the Ontological Status of the Unborn." In *Abortion and the Status of the Fetus.* Boston: D. Reidel, 1983.

McCormick, Richard, S.J. "Rules for Abortion Debate." In *Abortion: A Reader,* edited by Lloyd Steffen. Cleveland: Pilgrim Press, 1996. Also in *America,* July 22, 1978.

Messenger, E. C., ed. *Theology and Evolution.* London: Sands, 1949.

Miethe, Terry. *Augustinian Bibliography, 1970–1980.* Westport, Conn.: Greenwood Press, 1982.

Moore, Keith. *Essentials of Human Embryology.* Philadelphia: Decker, 1988.

Morowitz, Harold, and James Trefil. *The Facts of Life: Science and the Abortion Controversy.* New York: Oxford University Press, 1992.

Müller, E. *Das Konzil von Vienne.* Münster, 1934.

Nagel, Thomas. *Mortal Questions.* Cambridge: Cambridge University Press, 1991.

―――. *The View from Nowhere.* Oxford: Oxford University Press, 1986.

Nelson, James. "Protestant Attitudes toward Abortion." In *Abortion: A Reader,* edited by Lloyd Steffen. Cleveland: Pilgrim Press, 1996. Also in *Between Two Gardens: Reflections on Sexuality and Religious Experience.* Cleveland: Pilgrim Press, 1983.

Nicholson, Susan Teft. *Abortion and the Roman Catholic Church.* Knoxville: Religious Ethics, 1978.

Noonan, John. "An Almost Absolute Value in History." In *The Morality of Abortion,* edited by John Noonan. Cambridge: Harvard University Press, 1970.

―――. "The Experience of Pain by the Unborn." In *New Perspectives on Human Abortion,* edited by Thomas Hilgers. Frederick, Md.: University Publications of America, 1981.

Nordenskiold, Erik. *The History of Biology.* Translated by L. B. Eyre. New York, 1935.

Olson, Eric. "Was I Ever a Fetus?" *Philosophy and Phenomenological Research* 5 (1997).

Oppenheimer, Steven, and George Lefevre. *Introduction to Embryonic Development.* 3d ed. Englewood Cliffs, N.J.: Prentice-Hall, 1988.

Outler, Albert. "The Beginnings of Personhood: Theological Considerations." In *On Moral Medicine,* edited by Stephen E. Lammers and Allen Verhey. Grand Rapids, Mich.: Eerdmans, 1987.

Paul VI, Pope. "Pourquoi l'eglise ne peut accepter l'avortement." *Documentation Catholique* 70 (1973).

―――. "Respect for Life in the Womb." In *On Moral Medicine,* edited by Stephen E. Lammers and Allen Verhey. Grand Rapids, Mich.: Eerdmans, 1987.

Perry, Michael. *Love and Power: The Role of Religion and Morality in American Politics.* New York: Oxford University Press, 1991.

Popper, Karl. *The Open Society and Its Enemies,* vol. 1: *The Spell of Plato.* Princeton: Princeton University Press, 1950.

Porter, Jean. "Individuality, Personal Identity, and the Moral Status of the Preembryo: A Response to Mark Johnson." *Theological Studies* 56 (1995).

Quinn, Philip. "Political Liberalisms and Their Exclusions of the Religious." *Proceedings and Addresses of the American Philosophical Association* 69, no. 2 (1995).

Rachels, James. *Created from Animals: The Moral Implications of Darwinism.* Oxford: Oxford University Press, 1990.

―――. *The Elements of Moral Philosophy.* 2d ed. New York: McGraw-Hill, 1993.

―――. *The End of Life: Euthanasia and Morality.* Oxford: Oxford University Press, 1986.

―――, ed. *Moral Problems.* New York: Harper Collins, 1979.

Rahman, Fazlur. "Birth and Abortion in Islam." In *Abortion: A Reader*, edited by Lloyd Steffen. Cleveland: Pilgrim Press, 1996.

Ranke-Heinemann, Uta. *Eunuchs for the Kingdom of Heaven*. New York: Doubleday, 1990.

Rawls, John. "Justice as Fairness." *Philosophical Review* 67 (1958).

———. *Political Liberalism*. New York: Columbia University Press, 1993.

———. *A Theory of Justice*. Cambridge: Harvard University Press, 1971.

Reichmann, James, S.J. *Philosophy of the Human Person*. Chicago: Loyola University Press, 1985.

Ruff, Wilfried. "Das embryoale Werden des Individuums." *Stimmen der Zeit* 181 (1968).

———. "Das embryoale Werden des Menschen." *Stimmen der Zeit* 181 (1968).

———. "Individualität und Personalität in embryoanalen Werden." *Theologie et Philosophie* 45 (1970).

Scruton, Roger. *Sexual Desire*. Boston: Free Press, 1986. Also in *Applying Ethics*, edited by Jeffrey Olen and Vincent Barry. Los Angeles: Wadsworth, 1996.

Shannon, Thomas, and Allan Wolter, O.F.M. "Reflections on the Moral Status of the Pre-Embryo." *Theological Studies* 51 (1990).

Steinbock, Bonnie. "Adultery." In *Values and Public Policy*, edited by Claudia Mills. New York: Harcourt, Brace, and Jovanovich, 1992.

———. *Life before Birth*. New York: Oxford University Press, 1992.

Sumner, L. W. "Abortion: A Moderate View." In *Contemporary Moral Problems*, edited by James White. Minneapolis: West Publishing, 1997.

Tauer, Carol. "The Tradition of Probabilism and the Moral Status of the Early Embryo." In *Abortion and Catholicism: The American Debate*, edited by Patricia Jung and Thomas Shannon. New York: Crossroad, 1988.

Teilhard de Chardin, Pierre. *The Phenomenon of Man*. New York: Harper and Row, 1959.

Thomas Aquinas, St. *In omnes S. Pauli Apostoli Epistolas*. Turin: Marietti, 1929.

———. *On Evil*. Notre Dame: University of Notre Dame Press, 1995.

———. *On the Power of God*. Westminster, Md.: Newman Press, 1952.

———. *On the Truth of the Catholic Faith*. New York: Hanover House, 1955. Also *Summa Contra Gentiles*. Rome: Marietti, 1961.

———. *Scriptum super libros sententiarum*. Paris: Lethielleux, 1929–47.

———. *Summa Theologiae*. Blackfriars edition. New York: McGraw-Hill, 1970.

Thoreau, Henry David. *Walden*. New York: New American Library, 1980.

Tooley, Michael. "Abortion and Infanticide." *Philosophy and Public Affairs* 2 (1972).

Wade, Francis, S.J. "Potentiality in the Abortion Discussion." *Review of Metaphysics* 29 (1975).

Waldron, Jeremy. "Religious Contributions in Public Deliberation." *San Diego Law Review* 30 (1993).

Wallace, William, O.P. "Nature and Human Nature as the Norm in Medical Ethics." In *Catholic Perspectives on Medical Morals,* edited by Edmund Pellegrino. Dordrecht: Kluwer, 1989.

Wenz, Peter. "The Law and Fetal Personhood: Religious and Secular Determinations." In *Abortion: A Reader,* edited by Lloyd Steffen. Cleveland: Pilgrim Press, 1996. Also in *Abortion Rights as Religious Freedom.* Philadelphia: Temple University Press, 1984.

Westfall, Richard. *The Construction of Modern Science: Mechanisms and Mechanics.* Cambridge: Cambridge University Press, 1971.

Whelton, Beverly. "Human Nature, Substantial Change, and Modern Science: Rethinking When a New Human Life Begins." *American Catholic Philosophical Quarterly* 72 (1998).

Whitehead, A. N. *Science and the Modern World.* New York: Macmillan, 1925.

Index

Daniel A. Dombrowski is a
professor of philosophy at Seattle
University. This is his eleventh
book; he is also the author of
almost one hundred scholarly
articles, mostly in philosophy
and theology journals.

Robert Deltete is an associate
professor of philosophy at Seattle
University. He received his doc-
torate from Yale. His publications
are mostly in the area of philo-
sophy of science.

Typeset in 9.5/14 Trump Mediaeval
Designed by Copenhaver Cumpston
Composed by Jim Proefrock
at the University of Illinois Press
Manufactured by Thomson-Shore, Inc.

University of Illinois Press
1325 South Oak Street
Champaign, IL 61820-6903
www.press.uillinois.edu